satterwhite
ON COLOR AND DESIGN

W9-BRX-189

By Joy Satterwhite
and Al Satterwhite

20 MPH

Amphoto

satterwhite
ON COLOR AND DESIGN

SOUTH KITSAP SCHOOL DIST 402
1962 HOOVER AVE S.E.
PORT ORCHARD, WA 98366

AN IMPRINT OF WATSON-GUPTILL PUBLICATIONS
NEW YORK

Unless otherwise indicated, all photographs in this book
have been previously copyrighted © by Al Satterwhite
and all rights to them remain in his possession.

First published 1986 in New York by AMPHOTO,
an imprint of Watson-Guptill Publications,
a division of Billboard Publications, Inc.,
1515 Broadway, New York, NY 10036

Library of Congress Cataloging in Publication Data

Satterwhite, Joy.
 Satterwhite on color and design.

 Includes index.
 1. Color photography. I. Satterwhite, Al.
II. Title.
TR510.S23 1986 778.6 86-14002
ISBN 0-8174-5804-2
ISBN 0-8174-5805-0 (pbk)

All rights reserved. No part of this publication may be
reproduced or used in any form or by any means—graphic,
electronic, or mechanical, including photocopying, recording,
taping, or information storage and retrieval systems—without
written permission of the publisher.

Manufactured in Japan

2 3 4 5 6 7 8 9 / 91 90 89 88

Special thanks to:

All the creatives who came up with the concepts and trusted us to execute them;

Assistants, stylists, talent, modelmakers and everyone else who contributed to the success of our work;

Bruce Wodder for all his assistance with this book and otherwise.

CONTENTS

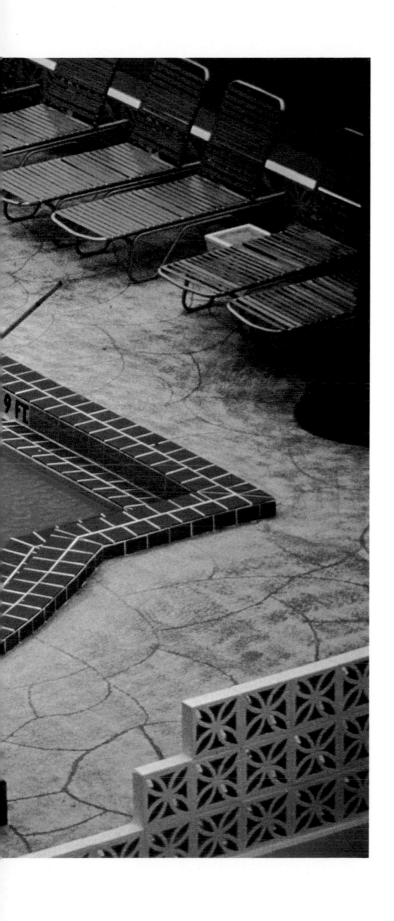

JOY D. SATTERWHITE
MEMBER'S NAME
SIGNATURE
11/13/89
EXPIRATION DATE

Joy Layman Satterwhite was born on December 2, 1953 in Washington, D.C. Except for a short period of living in North Carolina and in France due to her father's Air Force career, Joy spent her youth in Washington and the surrounding Maryland suburbs.

After high school graduation in 1972, Joy joined Image Devices Incorporated in Miami as a sound technician for ITN-Independent Television News, London. Besides being the youngest staff member, Joy was the first female ever to be hired by any camera crew. Miami became her base of operations for news assignments that sent her all over North and South America.

Whenever the royal family of England was traveling in her territory, Joy was there to cover it. She first met Prince Charles in the Bahamas, and traveled with the Queen on several occasions, the most memorable one being when Joy was presented to the Queen in Mexico. Because she had been working that day, Joy wore a black velvet gown and white sneakers to meet the Queen, who presented Joy with a silver bowl.

Joy also covered Watergate, and traveled with Nixon, Ehrlichman and other assorted characters. She spent a month in Santiago, Chile during the revolution (and had to smuggle film out of the country on her person) and covered many special docu-interest stories, such as the Alaskan pipeline and Muhammed Ali at his training camp in Pennsylvania.

During the Bahamas job Joy met Al Satterwhite, who was there covering the independence celebration for *Time* Magazine. Al encouraged Joy to model for some pictures, which led to her receiving acting and modeling assignments. She joined the Screen Actors Guild in 1973 and shot sixteen speaking roles in national TV commercials. Her print work appeared in many national magazines, including *Vogue*. The lure of big money convinced Joy to quit working for the press and relocate in New York, where she spent six months with the Wilhelmina Models agency. She hated it—she wanted to use her mind again. Joy tried to get work with the New York networks, but they wouldn't take her because the unions were reluctant to accept females and the industry was rapidly switching to videotape which wasn't in Joy's background.

Fortunately, her modeling work had introduced her to some advertising agency people who helped her land a job at Doyle Dane & Bernbach as an assistant business manager in their television production department. She left Doyle in 1977 to become an assistant producer at Richard K. Manoff, where she worked on such accounts as Bumble Bee, Bolla and Cella Wines, National-Rent-A-Car, Welches, and Breakstone. She also designed audio-video programs that were used to pitch for new business, and she used her knowledge of cameras to film focus groups for the media department.

In 1981 Young & Rubicam recruited Joy for their well known television production department. Joy was hired as a full producer and produced commercials for such clients as Procter & Gamble, Dr. Pepper, Jell-O, and Manufacturer's Hanover Trust.

Shortly after joining Y & R, Joy and Al were married. Wanting more creative and executive freedom, in 1984 Joy decided to quit Y & R and join Satterwhite Productions, Inc., where she is co-owner and executive vice president of sales and production. She has used her nine years of advertising experience to triple Satterwhite Productions' net profits by improving its promotional advertising and project production, and creating good client relationships.

Al Satterwhite was born February 16, 1944 in Biloxi, Mississippi. As an Army "brat" he spent the first six years of his life living in Germany, New York, Indiana and North Carolina. He finally settled in St. Petersburg, Florida, where in junior high school he became involved in photography.

In high school, he was very active shooting events for the school yearbook and newspaper and in his junior year he was asked by the *St. Petersburg Times* to join their summer intern program. After high school graduation, Al attended the University of Florida, majoring in aerospace engineering. But he spent so much time shooting for the college paper and yearbook and, at the same time, freelancing for the St. Pete *Times* and United Press International that it dawned on him that photography was his real career choice. So he gave up his old dream of becoming a pilot and transferred to the University of Missouri, well known for its photography department.

Al eventually realized that he was way ahead of his classmates—he had been shooting professional press assignments for years. He decided to drop out of college and go on staff at the St. Pete *Times* which has quite a reputation for its photography. Six months later, Governor Claude Kirk asked Al to travel with him as his personal photographer and take pictures during his campaign for the vice-presidency of the United States. Al logged a quarter of a million miles in his six months of travel in Governor Kirk's Lear jet and was introduced to some very powerful people.

After a year, though, the thrill was gone and Al started to dream of working on assignments that would be published in major national magazines. Al joined Camera 5, a picture agency, and started doing assignments for such magazines as *Time, Newsweek, Sports Illustrated,* and *Life*. Al was quickly becoming known for the graphic design that was apparent in his work no matter what subject he was shooting. In 1974, he took his growing reputation along with tons of tear sheets to Los Angeles because he wanted to try another, more commercial area of photography—the corporate and advertising field.

In 1975, Al was selected for the *Who's Who in Photography* but he struggled for five more years in Los Angeles working for editorial clients to help make ends meet. He knew he had to move to New York if he really wanted to make it big in advertising and finally did so in 1979. At the same time he decided to join The Image Bank, a slide stock house that was quickly becoming number one worldwide because of the caliber of the photographers it was signing on exclusively. His first clients in New York were mainly corporate accounts and slowly but surely his reputation with those clients opened doors at the big advertising agencies—then the work started rolling in.

Over the years, Al has won many awards for his editorial, corporate, and advertising work and he still shoots for clients in all three areas. Portfolios of his work have been published in *Zoom, Camera 35, Popular Photography* and one was even given an entire issue of *Il Diaframma*, an Italian magazine. His personal photography work has been shown in galleries in Paris, Los Angeles, San Francisco, New York, and Rio de Janeiro.

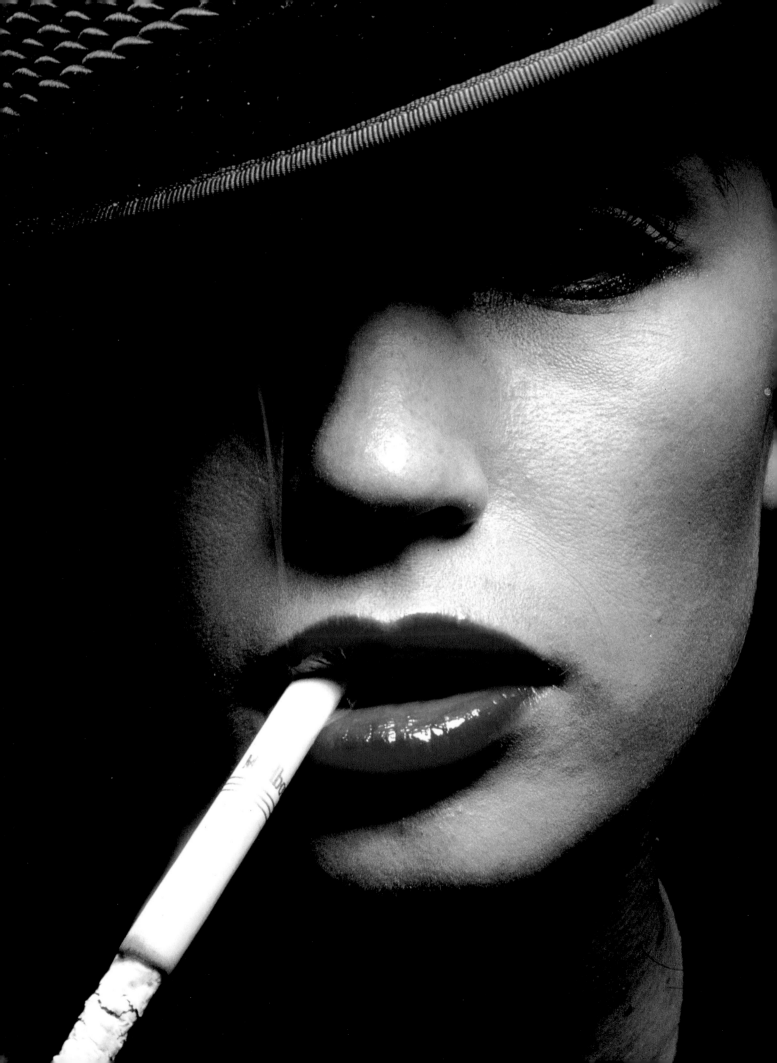

Introduction

I am frequently asked how I developed my style of shooting. That's a hard question for any photographer to answer; so many visual decisions are innate, rather than consciously made.

I took up photography as a hobby when I was in high school. Being the type of person who likes to observe from the sidelines, I discovered that with a camera I could get down in front and have the best seats in the house at any event. My camera was a tool that I used to gain entry to places I would otherwise never go. I could look at people through my camera and observe them without staring. Photography became my two-way mirror to the world—I could look out, but no one could look in.

Because of the work I had done for my high school yearbook I was recommended to the *St. Petersburg Times* for their student intern program. At the paper I started out shooting primarily black and white. I was developing my own work, so I could see instantly the results of that day's shooting. I was covering events in a "shoot and run" style—there were four deadlines per day that I had to meet. I had to learn to be fast and furious.

I shot a little bit of color while I was working for the paper, but I didn't really begin to understand color and design until several years later when I started working for the governor of Florida. I applied my knowledge of black and white to my color work, but adjustments had to be made. My out-of-focus backgrounds became more important now—a big blob of color in the background could draw the attention away from the foreground and change the intended focal point, which in this case was usually the governor.

I learned a lot about color and composition by looking at other photographers' work in books and magazines. Ernst Haas' work always impressed me—it was so strong and vibrant in its design—and I really felt drawn toward his photographs. Pete Turner's bold use of color also intrigued me. Pete is good with design, but Ernst's pictures appealed to me on a deeper level. They were eye-catching and provocative. This became the goal that I wanted to achieve in my photography.

It took a lot of trial-and-error to bring my work to where it is today. I'd try a lot of different approaches, different angles, different lenses, and different types of lighting. It really boiled down to practice and lots of shooting. I've always insisted on editing my own work—every frame of it—because I still want to see what I've done and think about how I could improve it if I got the chance. I've always worked out all the variables. Gradually, I began to see what was possible and what worked for me. The results were a distillation of everything I had tried and learned over the years. Most of what I've tried I threw away, but a lot of gimmicks had to be used before they could be laid to rest. I learned that there are no short cuts; all the mistakes had to be made. You simply stay at one level in your work until you get it out of your system, then you can move on.

As I practiced, I concentrated on what I liked in the viewfinder. I found myself gravitating toward design and strong colors; I'm always trying to make my photographs as simple and "clean" as possible, without any clutter. In the beginning I was taking pictures, now I'm *making* pictures. My style of shooting is very deliberate and I make very careful choices about what is included in the frame. Cropping, lighting, and color are an integral part of my method of designing.

I don't just look at people, places and things when I shoot; I see them as objects and play with their various shapes in my mind's eye. Take hats, for instance. I love hats because they provide natural frames for faces. Hats can be worn in a variety of ways and each will express a different attitude. Hats not only frame faces, they create shadows—and shadows are great for adding design. It's kind of like geometry; the subject moves and a shadow first seen in the shape of a triangle will change to an elliptical half-circle, which might work better with the subject matter. That's what I mean by playing with shapes—I imagine the movement of the light source and the effect it will have on both the subject and the image as a whole.

I love to work with hot, bright colors because they jump off the page. I don't like weak color—it doesn't speak to me. Design and placement have everything to do with making color work within the frame. I want strong color to connect with an emotion in the mind's eye of the viewer. I want it to reach out and grab them.

The design is what makes the image work, but the colors are what will set the design apart—or break it up. You can't just inject some bright color anywhere; it won't fit. It may cause the photograph to become overbalanced or to not work at all. To use color successfully, you must begin by seeing color as an organic part of the picture, not as a tool for manipulating or fixing a design that lacks impact.

In the end, design is really an exercise for your photographic skills. Design makes the viewer interested enough to look at the photograph long enough to get the point. But there must be something else in the photograph that effects your emotions. A picture taken strictly for design doesn't last. It's not really strong enough to stand on its own for very long without making that other important connection. The real test of a photograph comes several years later: Does it still speak to you? Does it make you feel anything? That's the whole point of a good photograph.

Introduction

I still experiment a lot and am constantly shooting—even when I don't have an assignment. I always carry a 35mm Minox in my pocket so that if something catches my eye I can at least take a snap to file away as a visual reference. I've stumbled onto some great ideas this way and have often recreated them later.

The majority of my work now is shot on location. I like to work with the unpredictability of nature. I don't scrub the shoot if the weather changes; I work with the change. I use the setting—the landscape or the architectural background—as part of the design, specifically integrated with the other elements in the frame to make a pattern. I don't want to just shoot "snapshots"—and I don't shoot until I feel that the image works. I get totally involved in creating and playing with the elements of the shot until I am happy with the design—then I shoot.

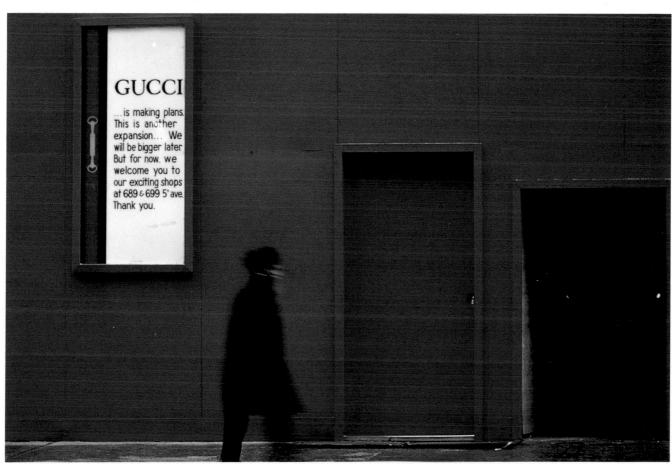

GUCCI

...is making plans.
This is another
expansion... We
will be bigger later
But for now, we
welcome you to
our exciting shops
at 689 & 699 5ᵗʰ ave.
Thank you.

When I receive an editorial assignment, I'm verbally given an idea which I have to translate into a photograph that the public will understand. I take the time to study the situation or environment involved and think about what the picture editor needs to illustrate the story. I'm free to experiment and there's no one with me for whom I have to perform. The responsibility is all on my shoulders.

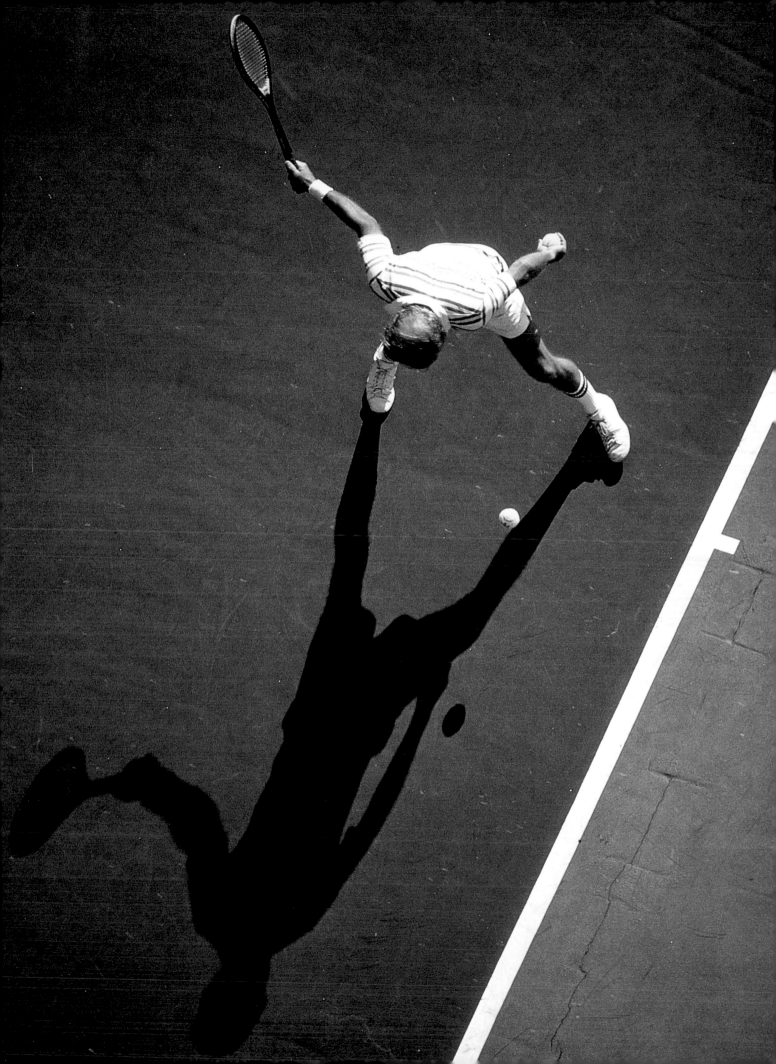

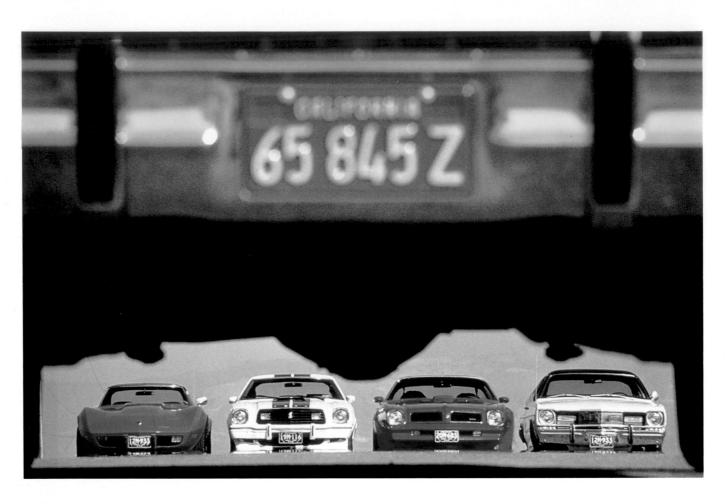

My corporate work was many times simply a question of design; making an interesting photograph from what at first glance appeared to be nothing. These pictures did not have to sell; they did not have to make a point; they *did* have to be visually stimulating and exciting. The big challenge was to tie it all up in a photograph. Of course, this is true only of annual report work; corporate advertising is identical to regular advertising—it's all about selling.

Introduction

When creating photographs for an advertising client, there is always a specific point to be made. My pictures are always trying to sell a product in some fashion. The best advertising photographs are self-contained, with the point being made by the picture itself; others may need copy to complete them. Both approaches are valid, but the complete photograph is always the best because it can stand on its own.

In advertising, I usually don't have the luxury of time to experiment. I have to draw on my experience and just go for the right shot. I'll be given a layout or a drawing to work from—it's all very structured. That's not to say I don't try to enhance the idea—I do—but I have to deliver the shot that was sold to the client by the advertising agency first. When I'm given an assignment, I try to get in on the planning of the shoot as early as possible. I like to have a say about what colors are considered and how they're going to be used. If I don't get involved in the beginning, it may be too late to make changes or suggestions.

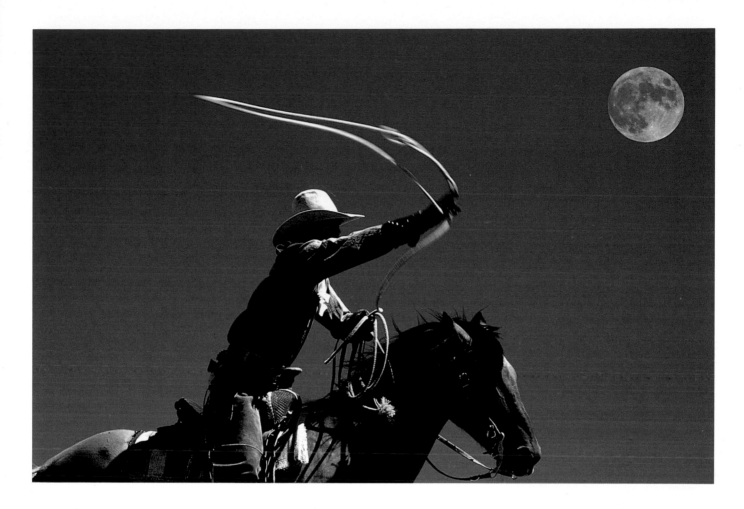

Advertising appeals to me because it is a tremendous challenge and usually has the largest budgets, which means I can create concepts from scratch. Corporate is also a challenge, but with less control and smaller budgets—I use my ability to make the most of what is available at the location within a brief amount of time. Editorial is the most free and unstructured—your reputation is on the line as you think of ways to create with a very limited budget and pressing deadlines.

All three forms of photography involve varying degrees of challenge, but their visual problems and solutions are similar; you must come up with something really good within the constraints of what you have at your disposal. The key factors involved in each are skill, time, and money, and they all depend on me—the photographer.

Both approaches to photography—the structured and the unstructured—appeal to me. I love variety so I wouldn't give up either one for the other.

Section One

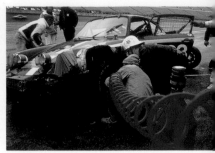

Young photographers from the world over seek out Al's advice on their work and careers. The question most frequently asked by these young hopefuls is: "Okay. I've been shooting for a while now. How do I get my first job? How do I get my work in print?" They want gratification; they want their work before the public. They want to earn a living with their skills. For them, photography has ceased to be a hobby and has now become a career goal.

In this chapter I'll explain how you can begin a career by shooting for newspapers and magazines. Al started in editorial work and he still feels that it's the easiest way for the unpublished to get published. Even if your ultimate goal is corporate or advertising photography, editorial work will be a valuable stepping stone toward either field. Both the corporate and the advertising client will expect you to show samples—preferably published samples—exhibiting fully developed lighting skills and the ability to work with complicated setups. In addition, either field will require a substantial up-front investment on the photographer's part, which editorial does not.

Twenty years ago, Al was shooting for his high school paper in Florida when he heard that the St. Petersburg *Times* had a summer program for teenage photographers. Students were given assignments by the paper and the equipment with which to photograph them. Al jumped at the opportunity and was later asked to join the paper's staff while he was going to college. By working at the *Times*, Al was able to experiment with different camera formats, film types, and equipment before making the expensive investment of buying his own. Once he made his decisions, he was able to start building up his supply of camera bodies and lenses using the equipment allowance given to him by the paper.

But the most important reason for working on a newspaper is the credit line. No other form of photography gives the beginning photographer a credit line on a regular basis. A good part of your future success will depend on getting your name noticed. In addition to the credit line, keep in mind that in most cases the freelance photographer keeps his copyright when working for a newspaper or magazine. That makes editorial assignments a great source for building up your stock file, from which you can earn extra income. A further discussion of this lucrative area of photography is contained on pages 131–135.

As previously mentioned, editorial photography requires the least amount of initial investment when you're starting out. Your equipment needs are minimal and all your expenses (such as hotel, air fare, car rental, and meals) are directly paid for by the client. This means you don't have to float heavy expenses on your own while you're waiting to be reimbursed. Corporate and advertising clients require that you spend thousands of dollars up front and then bill them for your expenses—and it can take them anywhere from 30 to 90 days to pay you back.

Shooting corporate and advertising work will involve various degrees of production, but in editorial, the amount of production will depend on what you've been assigned to photograph. Straight photojournalism requires that you capture the event on film as it happens. You shoot what you see and don't interfere. In this field of photography, you're relying entirely on your skills. History isn't going to wait while you change to a wide-angle lens. That's why photojournalists will work with several camera bodies all at once, each with a different lens.

Shooting a feature story of general interest for a newspaper or magazine may require more planning and research, but more often than not you'll still be dependent on those photojournalistic skills. Feature work is controlled to a large extent by the photographer. The angle you use, the lighting you choose, the placement of the subject within its surroundings—all of these factors determine how you will be presenting the subject to the audience. Feature work allows the editorial photographer the type of control over a photograph that can never be allowed when covering a straight news event.

EDITORIAL PHOTOGRAPHY

Newspapers employ photographers on staff, as stringers, and as freelancers, depending on the size of the paper and the assignments available. Magazines may have full-time staff photographers, but more often than not they work with freelancers specifically chosen for each feature story. There are also agencies that supply pictures (in the case of AP and UPI) or photographers (in the case of Magnum and Blackstar) on a contract basis to both newspapers and magazines.

Magazines send writers out to locations first. They work up a draft of the story, which is then presented to a committee, whose members either accept the story or not. The amount of space allocated to the story is pre-determined, including whether it is a possible cover story. The photographer is selected, briefed, and then sent out on the assignment. The writer rarely travels with him; it would be redundant, and magazines are very much concerned with costs.

Many assignments are given over the phone. Sometimes you are given a finished story to read before you go, sometimes not. The photographer is turned loose and has to interpret the assignment the way he sees it when he arrives. The picture editor may give him suggestions of things he would like to see photographed, but usually the photographer is left to his own devices. If an editor is using a photographer correctly, the photographer will have been selected for his particular style, which represents the way he sees things. It's the photographer's job to give the editor not only what was expected, but also to surprise him with the unexpected.

So how are you going to convince a newspaper or magazine editor to hire you over all the other photographers? It's not enough to be dependable—something more important should set you apart from your competition. You want the picture editors to think of you first.

You may have the ability to always be in the right place at the right time and get the shot that everyone else missed. Or you might be known for a special skill, such as shooting sports or aerial photography. Or maybe your work has a certain look or a consistent style that is interesting and instantly recognizable. This is the case with Al's photographs—he's hired for his distinctively clean and graphic shots.

To start a career in editorial photography, you will need some examples of your work and a lot of persistence. Contact the picture editor of any publication that you are interested in working for. Picture editors will make appointments with you but keep in mind that they see a lot of photographers. They will be reluctant to give you an assignment without a track record from other publications. Don't lose faith; offer to shoot a job at no fee, or think up your own story and present them with the idea and the pictures. They may not be impressed with your story idea, but they will see that you understand how to carry out an assignment. Eventually you'll be hired for a shoot and you'll be on your way.

Editorial work, whether it's straight photojournalism or feature work, freelance or on-staff, offers the photographer freedom and variety that is found in no other photographic field.

 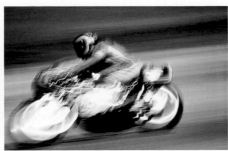

Shooting the Luge Competition

Geo (a travel magazine that is no longer published in America) was a great showcase for photographers. Their assignments were exciting and they loved to run lots of pictures. The photographs shown here were taken at the Luge Competition for the 1983 World Cup in Lake Placid, New York, and produced a good example of a typical *Geo* layout.

The editors at *Geo* were familiar with Al's work and wanted his view of the luge competition. The instructions were loose; "Shoot it from every angle and let's really show what luge is all about." They wanted Al to bring back pictures showing what went on, what happened on the sidelines, and what emotions were present at the events. Al got to speak to the writer before he left on the assignment, and he met with the writer at the site for a few introductions to specific people, but after that he was on his own.

Geo was very impressed with the outcome of this shoot. They ran three double trucks (a two-page layout, spread across the gutter of the magazine) of the best pictures. Flip through any magazine and you'll notice how rarely that happens. Remember too that these men were flying down the luge run—each shot was only suspended in time for a split second and then it was gone. A good editorial photographer must have fast reflexes.

Al—true to his style—kept each shot simple, and played up the bold primary colors that the team members were wearing. This was really an incredible feat if you stop and think how fast luge events happen.

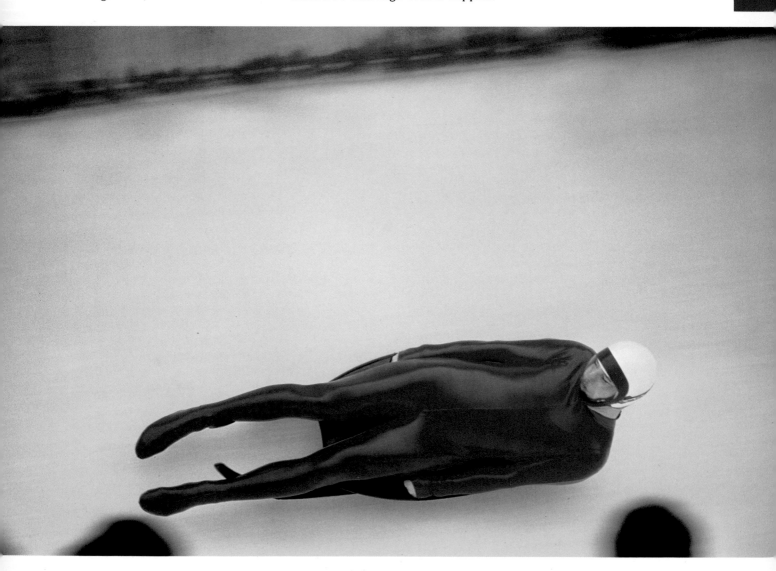

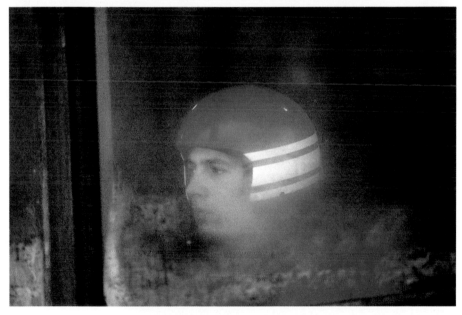

I like to shoot with 35mm cameras because they're easy to handle and offer the widest choice of lenses. And I like slow film; the slowest, sharpest, finest grain film you can buy—Koda-chrome 25. Most other photographers seem to find K25 a bit slow for their taste, but I love the sharpness and color that it produces. It has a wonderful color saturation, to a degree of which I've found in no other film. It feels *right* to me, and that's what's important. So that's my standard and as far as I'm concerned, nothing beats it, although I do use faster films for other purposes when absolutely necessary.

Because I use a very slow film I need very fast lenses. I love fast lenses for the clean, "no-background" effect they produce. Shot wide open, they show no depth of field. This gives my pictures a crisp, sharp look. With the background clutter eliminated, your eye immediately sees what I want you to see.

And, because I shoot wide open most of the time, I need very sharp lenses. Some of my favorite fast lenses are the Nikkor 135mm F2, the 200mm F2, and the 400mm F2.8. These are much larger than normal aperture lenses, but they're well worth the extra haul to get the effect I want.

I don't like to use a tripod if it's going to interfere with capturing a spontaneous shot that may happen around me, but when working with long and heavy lenses, they're very necessary. For panning and shooting fast action though, I don't use a tripod. It's all a matter of sense, timing, and how much help you have with you. Carrying around a couple of cameras with heavy lenses and tripods can really slow you down when you're moving around to cover an event such as this one. I had two assistants with me on this shoot, so we all carried a lot of equipment.

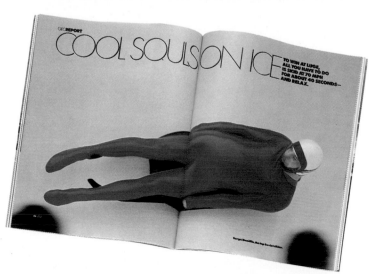

Al picked four primary spots to photograph from. One of them was a bad turn, which he felt was bound to come up with an exciting spill. Sure enough, a Japanese sledder soon lost his seating, but held onto the sled. The resulting shot produced one of the double trucks. You can also see that these shots were not cropped by the picture editor or art director; Al crops in the camera as he shoots. It's an important part of his technique. He likes to be in control of the outcome, rather than leave it up to an editor or art director who might not have a compatible sense of design.

In the beginning of his career, Al wasn't able to convince his clients that he needed an assistant—now he won't shoot without one. On an editorial assignment, an assistant is expected to carry the equipment and keep at least two camera bodies loaded and ready to shoot. At the same time, he must watch the photographer's back, making sure he doesn't fall off a cliff or get run over while concentrating on taking the picture. Most photographers work with four or five camera bodies at one time on editorial assignments. While the photographer is working with two or three bodies, the assistant can be reloading the others.

It's all part of being ready when events start to happen. The more preparation you take care of up front, the more time you can spend taking pictures—not just any pictures, but the pictures that say what you want them to say.

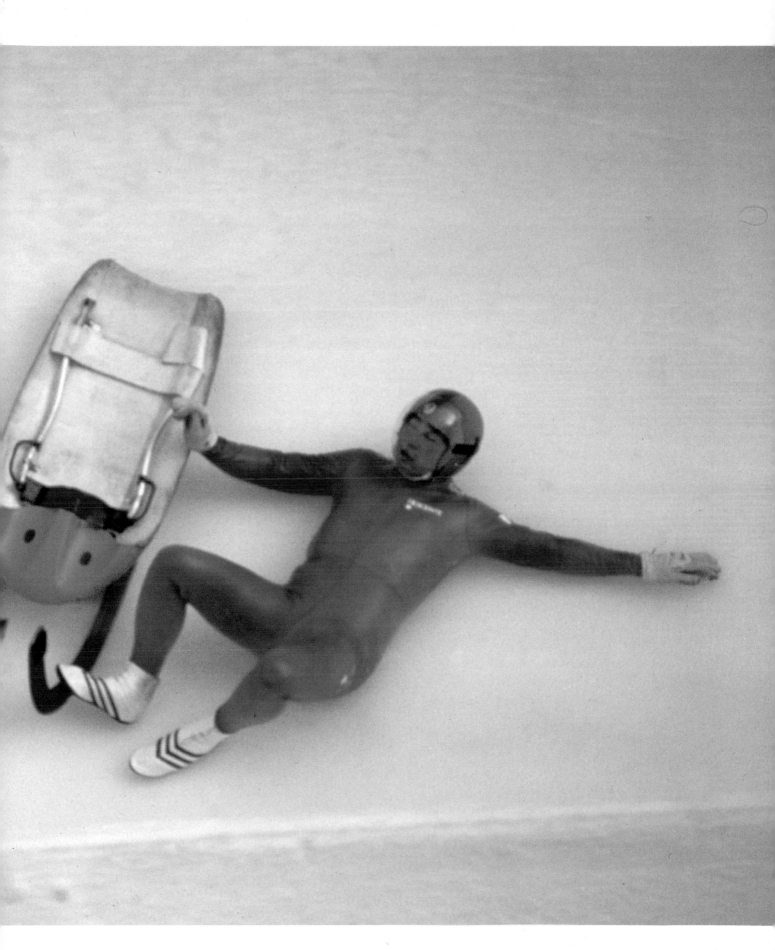

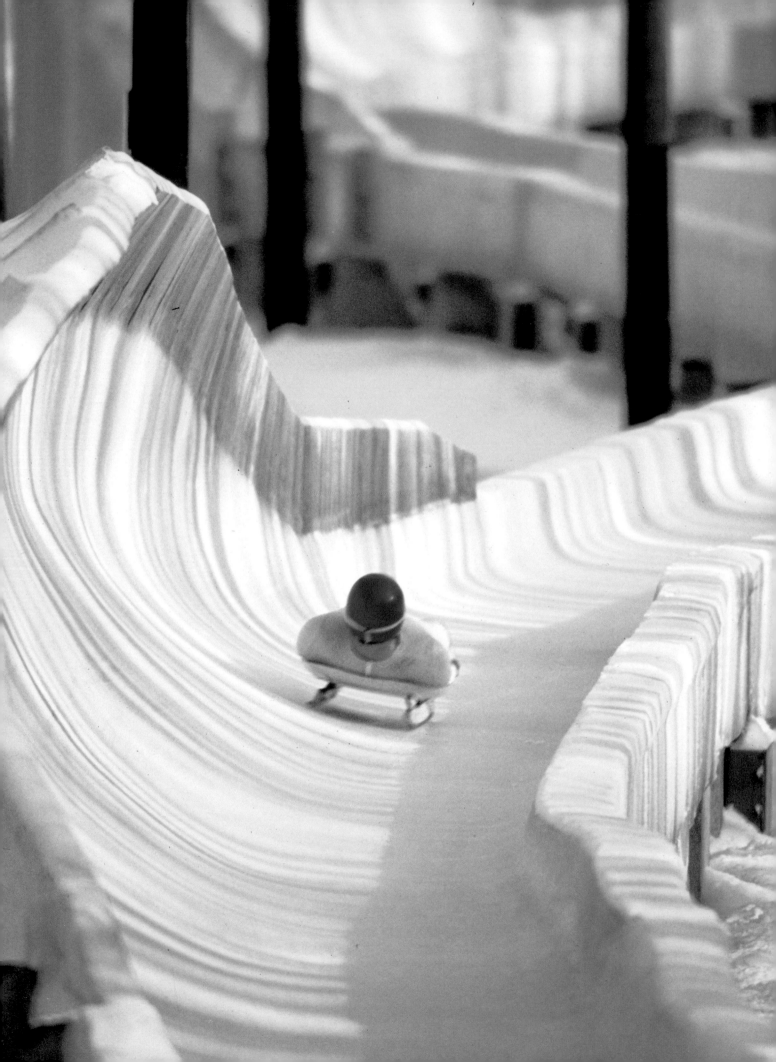

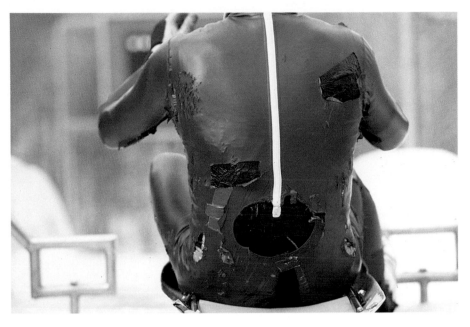

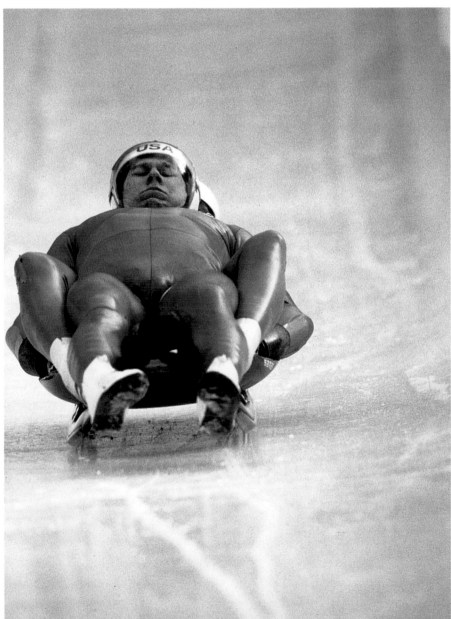

Shooting in cold weather can present many problems, but there are just as many tricks to overcome them. The biggest problems you'll encounter are with your film. In cold weather, film becomes very brittle and can break when you try to load it into the camera. Keep the film in an inside pocket where your body heat will keep it warm and supple. Practice loading; if you can load fast before the cold hits the film, you'll be home free.

Batteries can be a big problem too, They tend to slow down when cold. Combat this by changing batteries frequently or use an accessory battery with a cable. This will allow you to keep the battery in your pocket while you are shooting.

In the cold, motor drives can create static marks on the film as you're shooting. You can prevent this by applying liquid soap (the kind you normally use to wash your dishes) to the pressure plate and then carefully wiping it off.

If you are constantly shooting in cold weather (below 0°F), have your cameras winterized by a camera repair shop. This is done by removing all the lubricants from the inside of the camera. Just don't forget to have the lubricants replaced when you're heading for warmer locales.

Finally, don't touch cold, exposed metal on your equipment with your bare hands—your skin will stick to the metal. Keep your hands warm with interspace liners, which are available at most sporting goods stores. These liners can be worn inside your regular gloves. When you're ready to start shooting, you can whip off your outer gloves and maneuver very easily with the thin liners. The liners are also helpful in guarding against frostbite, which can be a real danger. You can't trip the shutter without your fingers—so protect them.

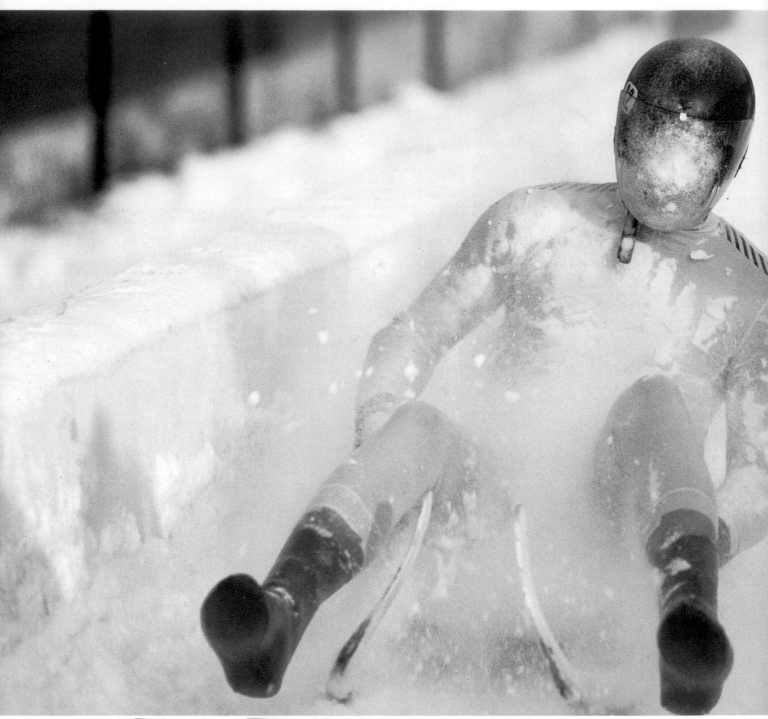

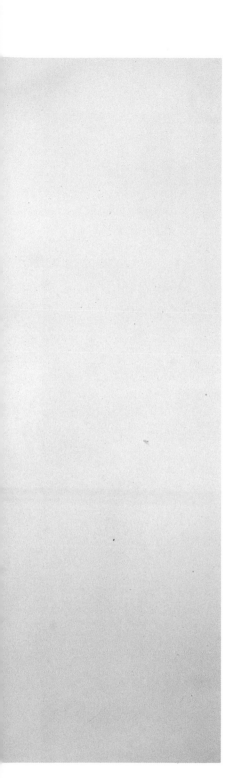

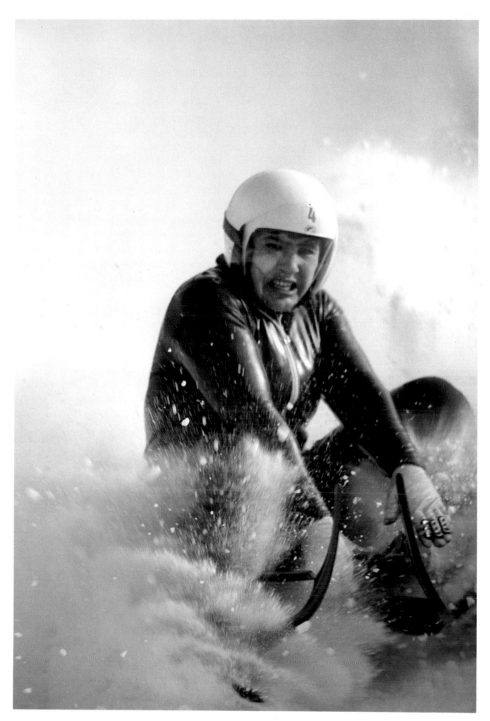

In a sports situation, such as this luge event, the most useful lenses are 600mm f/4, 400mm f/3.5, 300mm f/2.8, and 200mm f/2. But having the right lenses with you isn't enough. You have to get to the site early and scout out the situation. Find out the schedules of the event and pick your vantage points. Notice the sun; where—and when—does it rise and set? When the event gets started you won't have time to notice anything but the action, so it helps to be as prepared as you can at the outset.

Poolside Graphics in Hot Colors

Shooting for magazines isn't always a case of walking in and finding your subject matter ready and waiting to be photographed. Al was given this assignment on health spas for *Travel & Leisure* magazine and told to come back with a cover, as this was to be the feature story for the month. The magazine wanted something bold and graphic for the cover, which had to feature Kylene Barker Brandon, Miss America of 1979, who is the spokesperson for the Palm Aire Spa in Ft. Lauderdale, Florida.

The first task upon arrival at Palm Aire was to scout the club for possible shooting sites. It's always best to tour the entire area, making notes on what looks interesting, the type of light that's available, and the possibilities for shooting angles.

Al was intrigued by the room with the immersion pools, but was worried about finding the right vantage point—the lighting was provided almost entirely by a skylight. When the guide mentioned that she could electrically open the skylight and provide access to the roof—that was all Al needed to hear!

We were going for the cover here, but you never try to second guess the magazine's picture editor. Give him plenty of shots to choose from; shoot long shots, tight shots, different angles and formats (horizontal and vertical). The variety is appreciated in the end.

The assistant started clearing the area of any unnecessary items, such as benches, tables, and plants. While the shot was being arranged on the ground, preparation was beginning on the roof. The skylight was opened and Al's equipment was hauled up on the roof. A ladder was laid down over the opening in the skylight and Al crawled out into the middle. The cameras were clamped to the ladder with ball-and-head sockets. Color temperature and light readings were taken on the ground by the assistants and communicated up to Al.

Al shot every angle and variation of this setup that he could think of, and a take from the final series was chosen for the cover of *Travel & Leisure*. While his approach to Palm

Aire was different from his tackling of the luge, Al never lost sight of the purpose: to shoot great pictures that would communicate to the reader without compensating for his style. Here, he was able to explore, create, and build his shots, while on the luge run he had to work with the action as it occurred in front of his camera. Both jobs came out strong and graphic—and both reflect Al's style of shooting.

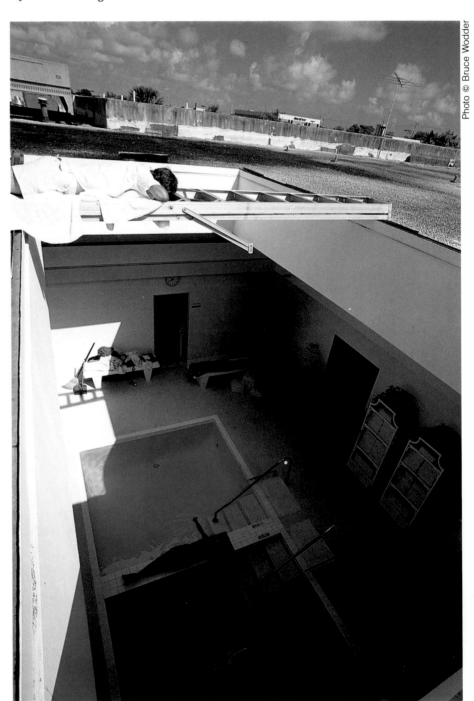

Photo © Bruce Wodder

I noticed the hot and cold immersion pools right away. They had the kind of symmetry that would be easy to design around. There was also a slight color difference in each pool; one was definitely paler than the other and the white tile surrounding them would make a perfect frame. But where would I shoot from? I needed to get up high to work with their shapes. When the guide said that it was possible to work from the roof, I knew in my gut that this was the cover shot; it's an instinctive feeling.

At first, we were working with yellow towels, which weren't very complementary to Kylene's skin tone. An assistant was sent in search of other warm-colored towels. I was hoping for bright orange or red. I like to work with a bright color. It draws the viewer's eye where I want it and helps to control the effect of the shot. I use color the way some photographers use perspective or other focal points.

My assistant took the color temperature readings with a meter and called them up from the ground. The color temperature meter is indispensible when you need to balance different types of light, or as an easy reference to what filter is needed to balance color with your particular film stock. The meter gives an indication of the color temperature of light in degrees Kelvin, translating this information into advice for the filter correction needed to balance the light according to the film type being used. For example, when shooting in cool light or deep shadow, the color meter would tell you to add a warming filter from the 81 series (A,B,C, and so on) to bring the light back to proper balance.

In the end, hot pink towels were found, Kylene was wrapped in one of them and positioned on the wall separating the immersion pools. The overall effect was looking good, but there was something missing. The shot needed more color, so yellow towels and a wicker towel shelf were added to the setup, with matching yellow bathmats placed by the pools. Now everything looked great. I really wanted the color to pop, so I underexposed by a third to a half-stop. I'll do this frequently to add richness to the colors of a scene.

I was ready to call it a wrap, but by this time the sun had changed position and shadows were being thrown in a corner of the room. The change in light added a whole new design element to the frame. This happens to me so often, I walk by many a great shot because the light isn't everything it could be. A location can change dramatically with the right light. A second and third look at different times of day should be mandatory. Try shooting the same spot in the morning, at noon, and in the afternoon and notice the change in the feeling of each picture.

I started out with a soft indirect light, which has a very nice quality for beauty shots. When the sun started to shift and throw hard shadows, it made things very dramatic and even more intriguing by increasing the contrast. With the soft light, the colors appear softer; with direct, hard lighting, the color saturation intensifies. The edges become more defined and stand out from the background instead of melting together. Hard edges make the design more evident.

This is what happened when the sun was going down and casting shadows in the room. It created great angles of shadows. A geometry major's dream—triangles and rectangles of dark and light. I loved it! I hurriedly set up to shoot again and shouted down for Kylene to put on the navy-blue swimsuit that I had seen her in earlier. I liked the suit because it had a good cut, yet it was simple and wouldn't detract from the rest of the shot. Something still wasn't quite right though. Joy suggested placing the hot orange towel under Kylene to introduce another color and shape. It was fabulous—the towel set off the line of Kylene's body and the color of her suit perfectly. This setup produced the magazine's cover photograph.

It's important to take time and work through a shot deliberately. That's how I get my best ideas. I don't rush; I build step-by-step and experiment. I rarely have the luxury of time to do this—time is money—but when I do play, I always turn out a classic shot.

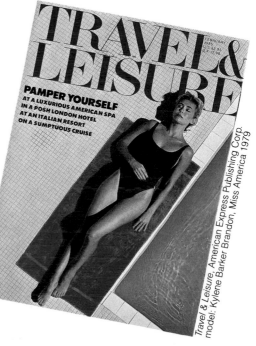

Travel & Leisure, American Express Publishing Corp.
model: Kylene Barker Brandon, Miss America 1979

A Robot's Gentle Grasp

This robot arm was photographed for the cover and an inside spread of *Next* magazine. The machine was shot on location at the facility where the robots are built. Al had no idea what the setup would be like before he got there, but assumed that the factory wouldn't be very photogenic. He brought a good selection of seamless backgrounds with him, along with a number of accessories—including the egg. That's part of the challenge of location work: you try to envision the scene, take everything with you that you think you might need, and then still be prepared for flexibility when the site is different than what you expected.

Reprinted by courtesy of *Next* magazine.

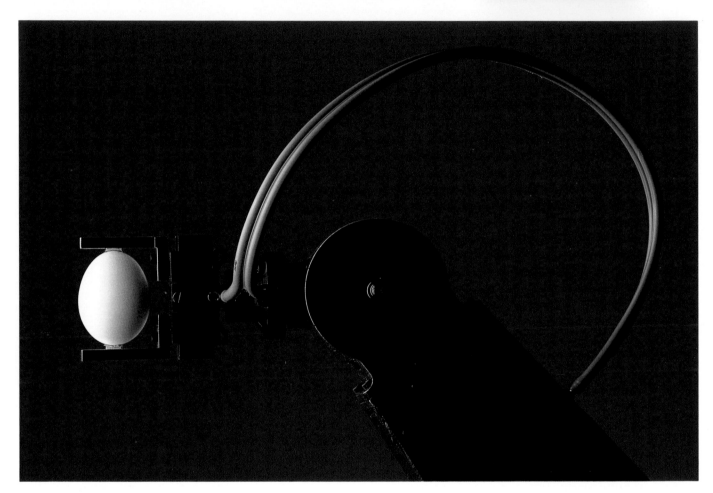

The idea behind this shot was to not only show the construction of a robotic arm, but to show just how far advanced the technology of the field had become. Hence the egg, which demonstrated the robot's delicate grasp and also happened to work very well to balance and counterbalance the shapes that made up the robot's arm. It also added white to contrast all the surrounding color.

Knowing that the factory would not provide a very attractive setting in which to photograph, I came prepared with a full selection of seamless backgrounds in a variety of colors. The red worked best with the black and gray of the robot arm, and the white of the egg.

The lighting was tricky—I not only had to make a piece of machinery look attractive, but also had to bring out the details of its construction, which was all black with a little gray.

Using a Nikkor 85mm F2 with Kodachrome 25, I set up a 3 × 4-foot bank light to the left of the robot, with a white board for fill to the right to lessen the contrast ratio. Two Luz 800-watt-second strobes were aimed directly at the seamless to even out the light from foreground to background.

An Infinite Relationship

There is a definite difference between shooting a cover and a layout for a magazine. Sometimes one comes out of the other, but often you'll shoot the cover alone.

The cover must be strong, clean, have space at the top for the magazine's logo, and space up the left or right sides for story captions. Covers are used to grab the consumer's attention; the rest of the layout informs the reader. Once the cover picture draws the viewer for a closer examination, they read the captions for content interest.

If Al is shooting an entire layout along with a cover, he'll keep the cover shot in the back of his mind as he's working, always looking for a likely situation that might lend itself to a cover. Or he might make suggestions for a specific cover photograph and discuss it with the art director or picture editor and then set something up.

Al can spend an entire day on a cover, whereas he might shoot several parts of a layout in the same amount of time. This cover, created for *Science '80* magazine, was to illustrate the idea of twins reunited. An infinity box not only helped to create a strong photograph for the cover, but also one that shows a relationship stretched out over time.

This shot really went contrary to my ideas about depth of field—the whole idea of the photograph depended on it. I used a Nikkor 55m F2.8 at f/22 and shot with Kodachrome 25. The infinity box was made by taking four optically flat mirrors, cutting them into 4 × 4-foot squares, and mounting them onto saw horses and wooden frames. Black velvet was hung at the bottom of the box to bring out the repeating image. A 4 × 4-foot bank light was hung over the top of the box. The models had to enter the box from the bottom. To help get as much depth of field as possible, the bank light contained four 1600-watt-second Luz strobe heads. The camera was placed at the top edge of the first mirror, pointed down to get the multiple images.

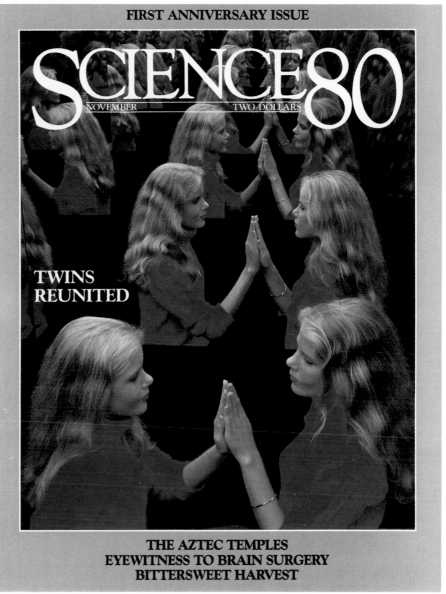

Science 80/AAAS

Infinity Box

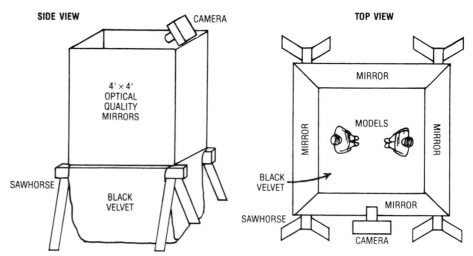

Covering a Story Overnight

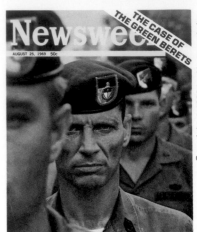

Copyright © 1969 by Newsweek, Inc.

Working on a shoot for one of the major news weeklies always carries the additional problem of tight deadlines. This cover shot for *Newsweek* magazine was no exception—both *Time* and *Newsweek* are notorious for waiting until the last minute to make a cover assignment. Al was simply told to fly down to Fort Bragg, North Carolina, where he would be met by a liaison officer who had precleared all the details. He had no idea what to expect or what he would shoot, except that the military was involved. In fact, there was only enough time to shoot four rolls of film in order to make the magazine deadline back in New York that same day.

I left Florida in the early morning and flew to Fayetteville, North Carolina, where I rented a car and drove to Fort Bragg. There I met with the magazine's writer and the officer from the Public Information Office and we got right to it. It was 1:00 PM when we started touring the barracks. I liked the looks of one particular platoon of men. I wanted to capture the intensity and seriousness of their gaze—to me, that was what the Green Berets were all about.

Their Commanding Officer had the men fall in line and I started shooting, alternating with two cameras. I used a Nikkor 85mm F1.8 for most of the shoot. The other camera carried a Nikkor 180mm F2.8 and I took some shots with it, but these were too tight, without much detail in the background. I liked the 85mm better and often use it or a 135mm for faces. (I didn't own a 135mm at the time). The cover shot was taken with the 85mm.

It started to rain while I was shooting and I only had time to take four rolls of Ektachrome because I was facing a tight deadline. Still, I felt comfortable with what I had shot.

I jumped in the car, headed back to the airport, and caught the next plane to New York City, arriving about 6:00 PM. I went right to Newsweek's *lab and dropped off the film, asking them to pull a clip test. I went to dinner, returned to the lab at 9:00 PM, looked at the test, and approved the run for the rest of the film. I went to my hotel and went to bed, knowing that the magazine's picture editor would have the film on his desk the next morning at 8:00 AM. I caught a flight back to Florida the same morning and didn't see the cover until the magazine hit the stands.*

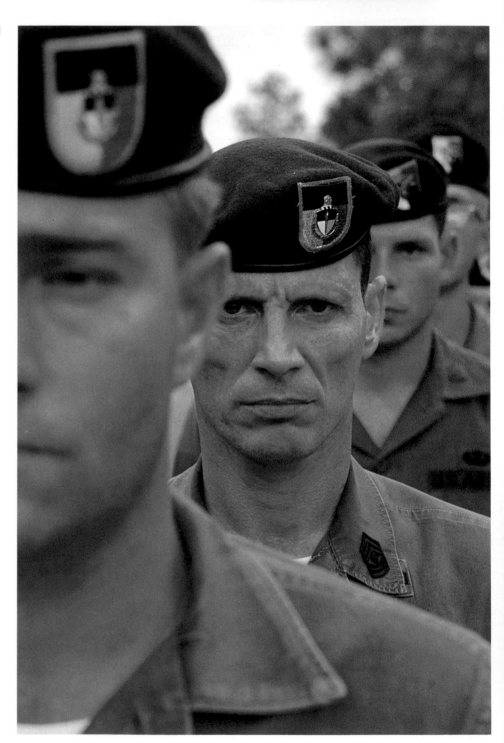

Trevino on the Green

This cover shot for *Golf Digest* was chosen from a larger take of the U.S. Open golf tournament. Shooting golf is as tough as any sport, even though it might not happen as fast. You can't break the player's concentration, so you have to use long lenses to shoot from a distance and you can't use a motor drive because of the noise it creates. Al tracks certain players when he photographs golf, being very patient, waiting until he sees something he likes, and then shooting.

I like this shot. I think it captures well the tension on Trevino's face while he was trying for a difficult putt. I was working with a Nikkor 600mm lens wide open at f/5.6 on a mono pod. I chose to work with Kodachrome 64, rather than my usual K25, because I wanted more contrast. I liked the colors he was wearing and knew he could handle the contrast of the K64 because he has great character in his face. He also wears a great hat— most of the players wear plain hats with no names. His hat helped to create the deep shadow under the bill of the hat. It's unusual to block out the eyes in a head shot, but I thought it would give the shot more drama. The set of his jaw line and tight lips gave away enough of the emotion—I didn't need it in the eyes.

Reprinted by permission *Golf Digest* magazine

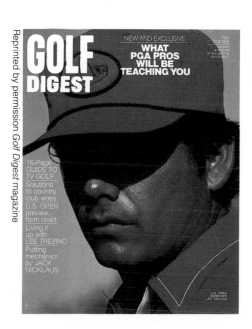

Paul Newman

Paul Newman was racing at the Bonneville Salt Flats in Utah. Al was on assignment for *Sports Illustrated* and he was the only photographer invited to the event. Newman is one of Al's favorite actors, so during the course of the assignment he spent time getting to know his subject. This extra time went a long way in capturing an unusual portrait of a much-photographed celebrity.

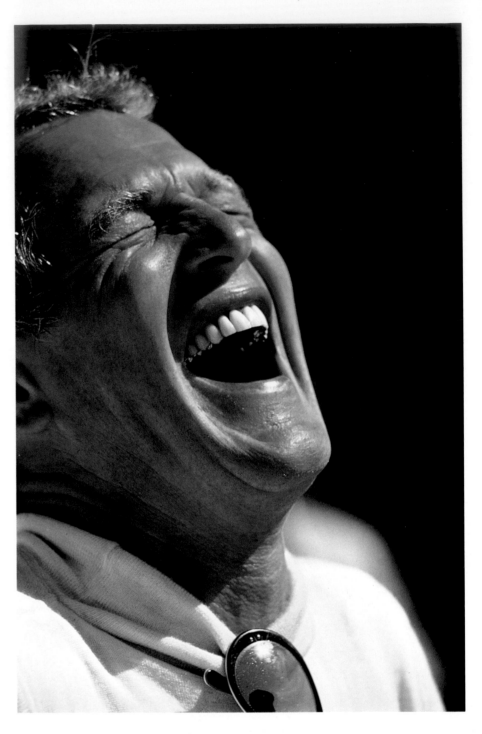

I love cars and Newman loves cars, but since we're both rather quiet, we didn't talk a lot for the four days I was there shooting. I stuck to him like glue, but stayed out of his way. It's my "fly-on-the-wall" approach, which I favor for editorial shoots of famous people. He had a job to do and it was nothing that I should interfere with, so I was careful not to intrude. I tried to stay on top of the action and capture his interaction with his co-drivers and his crew. This type of coverage provides better pictures than trying to set something up.

Sporting events such as this one usually involve a lot of male camaraderie, including some great joke-telling sessions with the pit crew. Newman enjoys a good joke, and I'd notice how he'd throw his head back when he laughed. It is one of the most genuine and elated laughs I've ever encountered—and I had to capture it on film. I think it tells a lot more about the man than just another shot of those famous blue eyes.

Putting a Book Cover behind Bars

This photograph of Freddy Pitts and Wilbert Lee was taken to illustrate a book cover. The author had heard of Al through his work for the Miami *Herald* and asked him to do the photograph. Pitts and Lee had been on death row for three years, sentenced for a crime they did not commit. The author's research brought forth new evidence and a new trial eventually resulted in their release. However, at the time this photograph was taken, they were still incarcerated and Al was not allowed to be in the same room with his subjects, hence the portrait behind bars.

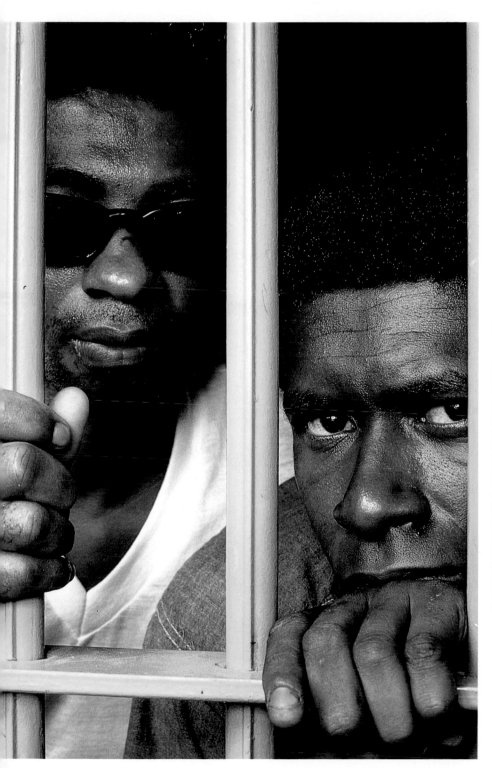

I decided to make the best of a bad situation and use the bars that separated me from Freddy and Wilbert to add to the design of the photograph. The bars also made for a photograph that brought home the point more directly than any simple portrait would have. The fluorescent light of the prison was not the most flattering light in which to photograph, so I brought along two umbrellas for bounce light, each powered by a Balcar 1200-watt-second strobe. These not only provided more even lighting, but added separation between the bars and the two men, further heightening the impact of the shot.

Doubleday and Co., Inc.

45

Reviving a Boring Composition

Al was photographing a three-day swim meet at a college in Los Angeles for *Sports* magazine. The lighting was boring and flat, which was making the assignment tedious for Al; he was getting discouraged because he couldn't come up with something great. Finally on the last day of the meet, he noticed a large, red-and-white striped tent and felt that it just might be used to add some interest to an otherwise dull group of pictures, and as usual, his intuition was right.

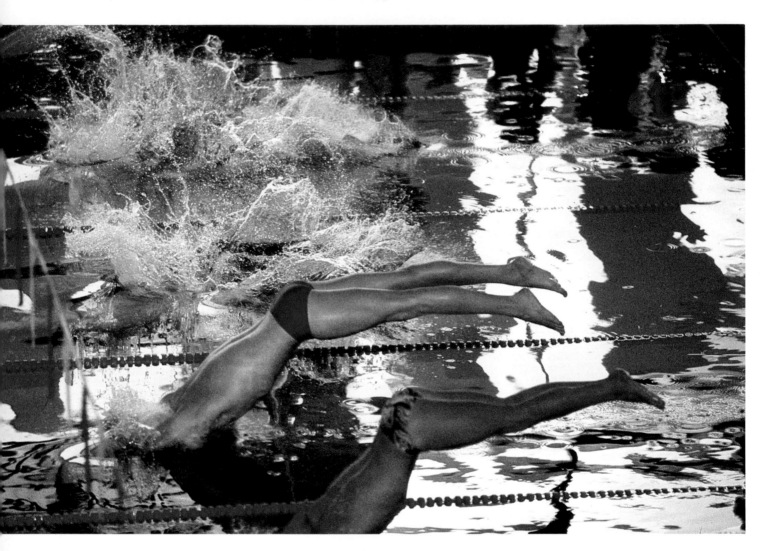

I noticed this red-and-white striped tent through the sliding glass doors at one side of the pool and thought how much the tent's pattern would resemble the stripes of the flag. If the doors were opened, the tent would reflect off the water of the pool, rather than the doors. It was just what I was looking for to add some drama and meaning to the shots of the swimmers. I positioned myself opposite the reflections and used some television lights to warm up the otherwise cool fluorescent lighting of the gym. I used a Nikkor 85mm lens wide open at f/2 and shot on High Speed Ektachrome. Later, I duped the shot onto Kodachrome 25 to boost the contrast and intensify the color.

Wrestling with Design

Sports Illustrated sent Al to cover the Collegiate Wrestling Championship in Denver, Colorado. Al knew that the magazine liked to run pictures showing different points of view on sports and wanted to shoot these wrestlers from a high angle. The high vantage point gave him a spectacular view of the action and it allowed him to design the wrestlers against the bright red mat.

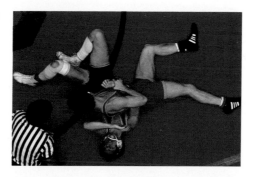

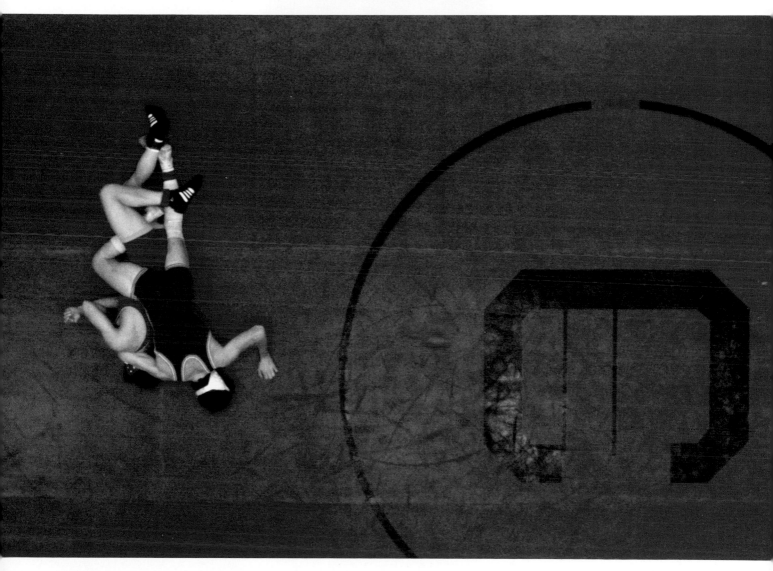

I really wanted to get up high to shoot the competition, so I convinced the promoters to allow me to photograph from the catwalks above the arena. I like to shoot down from above, and in this case, the high angle let me lose the clutter of the sidelines and the audience in the stands. I could sim-plify the contents down to just the wrestlers, the referee, and the graphics of the mat and its markings. I worked with both a Nikkor 180mm f/2.8 and a 300mm f/2.8 wide open with High Speed Ektachrome Type B pushed one stop. A Minolta color temperature meter helped to determine the right color correction filter.

Multiple Exposures on Ice

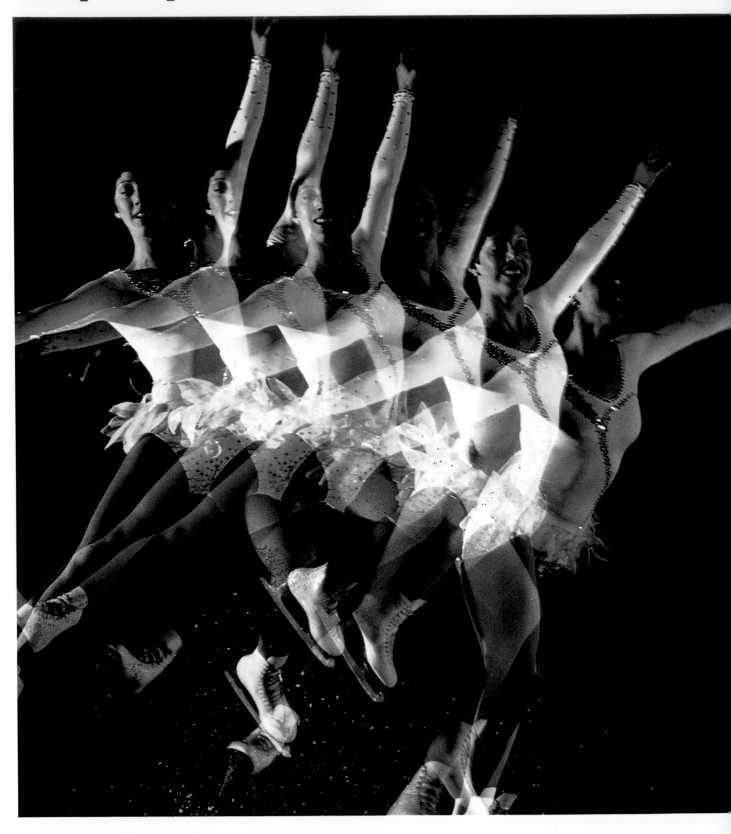

People magazine needed a shot of ice skater Linda Fratiani practicing for the upcoming 1980 Winter Olympics. Al came up with the idea for multiple exposures using strobe to capture the champion moving through one of her famous leaps. *People* thought it was great and approved the extra expenses. The rink was in total darkness, except for one small spotlight by which Linda could see to skate. Linda jumped 72 times

without a hitch, and the resulting shot was used by *People*, and by the Washington *Post* in their Olympic Preview edition.

A job as complicated as this needs as much pre-planning as possible. I mapped out most of the details on paper and discussed every item with my chief assistant. We had to figure out how many strobes we would need (determined by how many images I wanted of Linda on the final film), how many heads we would need, where they should be positioned, what to put them on to keep them off the ice, how to wire all of them together, how much AC cord was needed, how much amperage our strobes would be using, where the rink's electrical junction boxes were, how to darken the entire rink, how much black plastic to buy, how thick it should be, how long it should be, how many assistants would be needed to put it up, how many step ladders they would need and where to get them, how long would it take them to put it up, how much cord we would need to wire all the cameras together, and finally, where to place the cameras.

A crew of six assistants arrived at the rink at 4:30 AM and started taping black plastic over all the windows in the rink to block out the daylight. They then hung a piece of black velvet 8-feet high and 20-feet long in the center of the ice. This would provide the backdrop against which Linda would be photographed. While the different crews were doing their jobs, an assistant and I laid out all the wiring on the floor of the rink and color coded it. We wanted to be ready because we only had the rink for a couple of hours of shooting time. When our time slot came up, we rushed everything out onto the ice. Six 2400-watt-second Balcar strobes with 12 heads were set up to fire through a Strobo-Box. This is a device which allows you to control in milli-seconds the delay between the strobes firing in sequence. Six 35mm cameras were set up to fire at once. A 55mm f/2.8 lens was placed on each camera and all the shutters were set on Bulb. All the lights were turned out except for a small spot so that Linda could see. She was directed to skate to a mark on the ice and then leap in the air in front of the black velvet backdrop. Everything went according to plan.

Lighting *Swan Lake*

The Miami *Herald* sent Al to capture a dance company rehearsing *Swan Lake* for their Sunday magazine *Tropic*. He really enjoyed this assignment because he was allowed total freedom to wander the stage while the dancers were rehearsing. Al had to compensate for the low lighting on the stage, but fortunately he has steady hands from many years of practice.

Tungsten light is much warmer than daylight. If you shoot daylight film under tungsten light, the result will be a very, very warm picture—usually much too warm to look good. Kodak makes Kodachrome Type A film (ASA 40) balanced for tungsten light (3400K) and Ektachrome Type B (ASA 160) balanced for 3200K lighting. The Ektachrome and similar base films can be pushed one, two, or three stops for speed.

Stage lighting isn't always balanced for these films, so it helps to have a color temperature meter with you. I always carry one nowadays, but when I shot this picture they didn't exist. I used my experience and assumed that the stage lighting would be a little warmer than 3200K. It actually added a pleasant effect to the picture. I shot this with an 85mm lens wide open at f/1.4, hand-held at 1/15th sec.

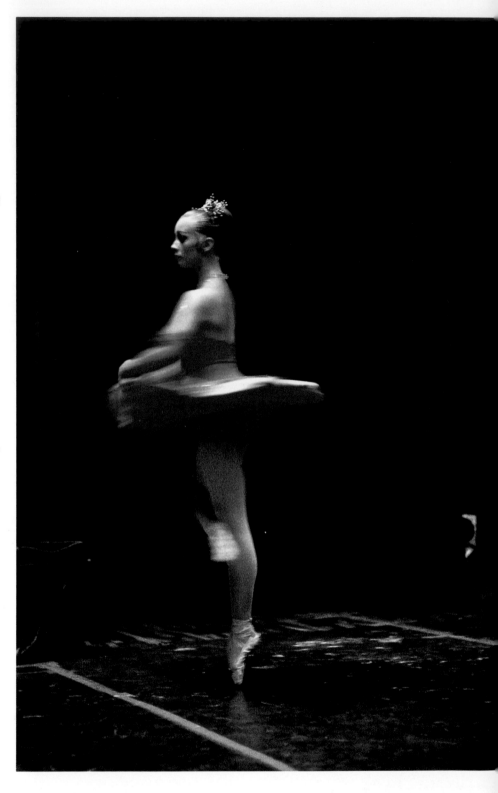

The Significance of Red

One of Al's favorite (and most well known) photographs, this beach scene was originally shot as part of an editorial layout on the Bahamas for *Travel & Leisure* magazine. They later picked it up for use in an advertising campaign.

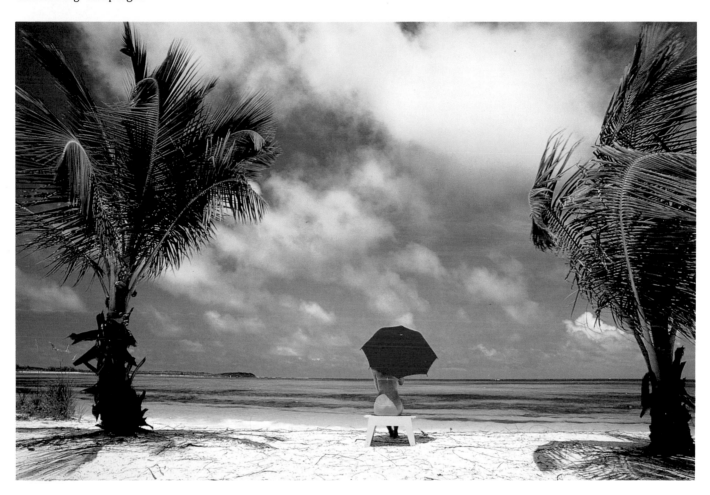

I didn't want to do the same old boring beach shot—blue sky meeting aqua sea. I knew that color would be the ticket to adding some interest, so I brought a full selection of different-colored beach umbrellas with me. The red one worked best. It was brilliant in the otherwise soft-colored setting. I saw this woman sitting on the beach and thought that the color of her suit would work well with the design. I convinced her to pose with the umbrella. I photographed at 1/60th sec. for the depth of field. Some movement in the palm trees was picked up—a happy accident. I shot on Kodachrome 25 with a Nikkor 28mm lens, wide open at f/5.6.

Travel & Leisure, American Express Publishing Corp.

Crazy about Cars

Al loves cars—he loves to drive them and to photograph them. Over the years he's done a lot of car work and has a whole arsenal of techniques he uses to get the most from the subject.

If you want to freeze a car in motion, use a very high shutter speed (at least 1/2000th sec.). Conversely, if you want to show the speed, use a slow shutter speed (1/15th to 1/60th sec.) and pan the camera with the car's movement. Remember that the car must be moving left to right or right to left, not toward or away from the camera. Side-to-side movement will keep the car fairly sharp and the background blurred—the slower the shutter speed, the faster the car appears to move.

Side lighting or front lighting is good for moving cars and backlighting will add more drama. Light-colored cars work better in motion; dark cars tend to "go black," or lose a lot of shadow detail.

When shooting stationary cars for "beauty" shots, Al prefers backlighting and exposes for the shadow detail. If you want to fill the shadows you're going to need a huge reflector. A white wall works well, or the side of a tractor trailer painted white. You can also use a large piece of white material stretched on a frame, but this is susceptible to high winds. Direct front lighting is usually uninspiring and dull, unless you use the sun when it's very low in the horizon to throw dramatic shadows.

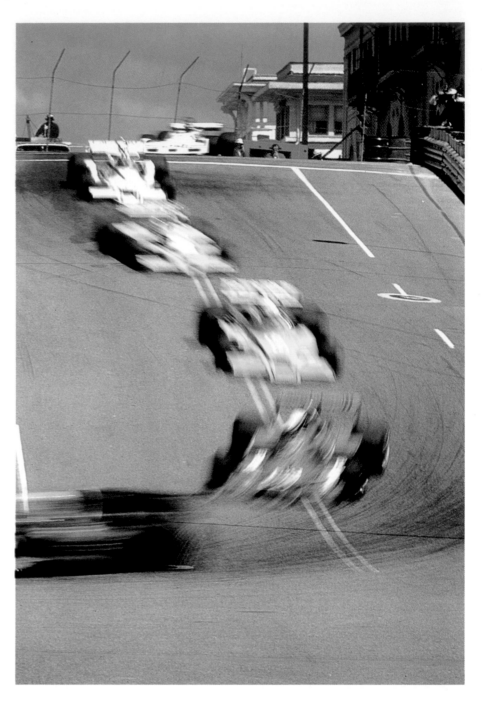

Long Beach, California has a "grand prix" race every year through the town's streets. There are a number of tight turns and a 180 mph straightaway. I shot from a high vantage point to eliminate as much of the crowds and background as I could. The cars in this photograph were coming onto a left hand turn at about 60 mph. I photographed them with a Nikkor 400mm F3.5 lens at f/22 and 1/15th sec., with the camera mounted on a mono pod. I wanted the slow shutter speed to blur the cars as they came around the curve and crossed the painted street lines. I think the result gives the shot a musical quality.

I noticed this car (right) at a race in West Palm Beach, Florida. I liked the colors and cropped in close using a Nikkor 180mm F2.8 lens. I almost always crop in the camera—as I did here. I don't like to make adjustments later in the printing unless I absolutely have to. That's why I shoot so much film; I want to shoot every interesting variation I can think of.

Crazy about Cars

This shot was taken as part of a story on imported cars for *Fortune* magazine. The cars were photographed in New Jersey on a road with freshly painted yellow stripes. Special permission had to be granted for the shoot, since one of the cars would be travelling on the wrong side of the road. Fortunately, the road was fairly isolated, so we didn't have much of a problem blocking traffic.

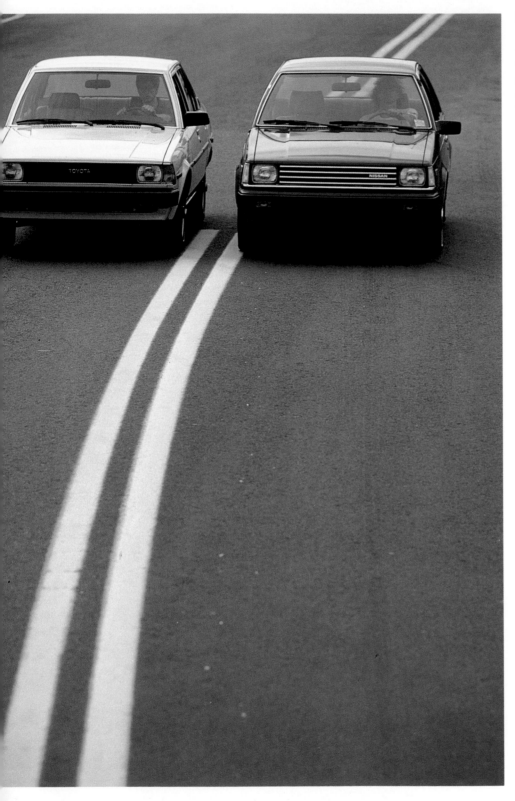

The double stripes were important in this shot. I wanted them to add depth and a strong design element to the picture. Without them, this would have been just an average shot of two cars driving down a road. I was positioned on top of a truck, facing backwards at the cars. My two assistants were driving the cars slowly down the road as I shot. The camera was attached to a Kenyon Gyro Stabilizer and I used a Nikkor 180mm F2.8 lens at f/16 and 1/30th sec. The film was Kodachrome 25.

Car and Driver magazine asked Al to illustrate an article on the new Ferrari 400. It was a photographer's dream—he could take the car out on the open road to find the right setting for the shots. An out-of-service gas station in Connecticut provided just the right elements of design that Al wanted.

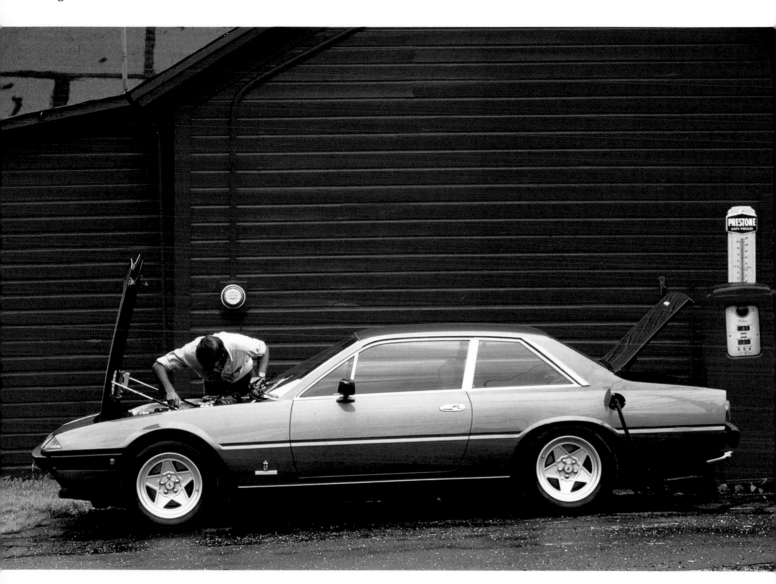

This is the kind of assignment I love—who wouldn't want to be handed the keys to a Ferrari for the day? When I saw the old gas station, I knew it would make the perfect background for the bright silver of the car's surface. Red is, if you haven't guessed by now, my favorite color to photograph and the car really popped when positioned against the texture of the painted building. Shot on Kodachrome 25, the contrasting colors make a strong design statement.

Crazy about Cars

This series of photographs taken for *Car and Driver* magazine combined simplicity and ingenuity to create an attractive layout to illustrate the Ford Cobra. They were taken near Palm Springs, California, a very beautiful and rugged setting. The action shots were simple enough; professional driver Don Sherman made several passes in the car while Al photographed. For the stationary shots, Al wanted the car to look as if it had been photographed in a studio, similar to a "beauty" shot of a model for advertising. Since we didn't have access to a large studio, Al had to make do with a little help from nature.

Car and Driver magazine

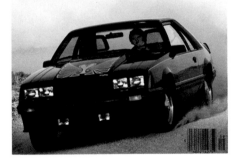

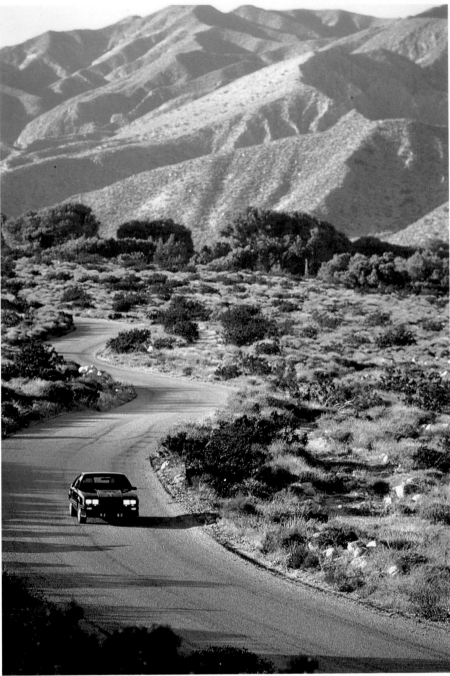

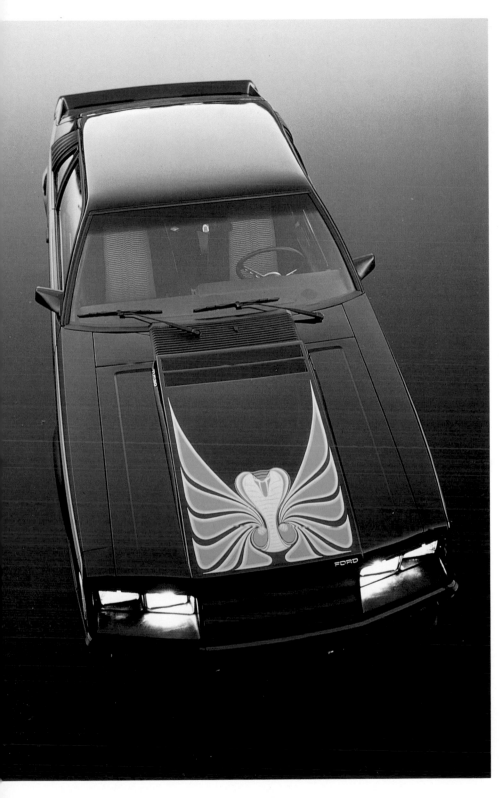

I wanted to highlight the dramatic lines of the Cobra and thought about photographing it on a surface that gave the appearance of shiny, black Plexiglas. This was going to be a little difficult in the middle of nowhere. We dug out a square area about 30-feet wide and 2-inches deep and blocked it with a wooden frame. The frame was painted black and then sealed to be water-tight. A wall, 30-feet wide and 12-feet high, was erected on the West side of the frame and painted white. The Cobra was driven into the center of the frame and the area was flooded with water to a level about 1½-inches deep. I shot from a high angle to eliminate the mountains. The sky was my bank light, reflecting off the water to give the appearance of a mirrored surface, and the white wall became a giant reflector.

This may seem like a lot of trouble to go through just to photograph a car, but it does take a lot of work to stay ahead of the crowd—it's what separates the pros from the everyday shooters. The "water box" created an unusual display that enhanced the car. I call this type of shooting my "out-door table-top" work.

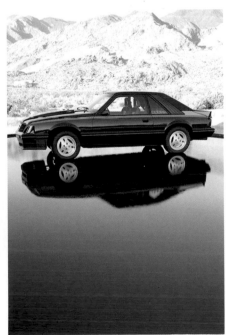

Section Two

 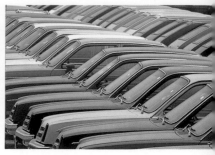

Corporate photography is what I call the "meat and potatoes" of the industry. You can decide on a career solely based in corporate work and—as long as you are competent, have a good eye, and your clients like you—you can earn a good living. Corporate photography pays a day rate that can range anywhere from $750 to $2,000, and most jobs book from two to eight solid weeks of your time. Of course, your overhead in this area is higher than editorial work, but it's nowhere near the level that advertising requires.

Ultimately, the point of corporate photography is to make a company look good. Your photographs will be used to represent the client to investors, in the case of an annual report, or to consumers, in the case of advertising.

Annual reports make up the bulk of corporate work, and they're typically seasonal, with most published at about the same time of year. Depending on the company, these reports often have production budgets that run into hundreds of thousands of dollars. Some annual reports feature higher quality reproduction than many magazines or books, and their design can be superb. One aspect of annual report work that is standard is a tight schedule. The majority are conceived, designed, and photographed in six months, and it's always a race to meet the deadlines.

As a photographer working in this field, you may find yourself shooting anything and everything—from an executive portrait, to photographs of people at work, to the exterior of a factory, to straight product shots. The corporate photographer must be versatile. Every setup is different, every lighting situation is different, and the only constant is change. Corporate photography is always a challenge—that's what makes the work so exciting. However, while the locations may sound exotic, they can also turn out to be dirty, out-of-the-way, manufacturing plants. You may find yourself with only five hours in which to accomplish your task before re-packing and rushing to catch your flight to the next location. And that next location may just be a shooting session with the corporation's president, which not only means switching to a different mind set, but also wearing a jacket and tie—no jeans!

Moreover if you don't like to deal with the problems of travel—misplaced luggage and equipment, a different hotel every night, lousy food and skipped meals, sleeping on planes, and waiting an hour or two to place a long-distance call from some "backwater" location only to find that the person you're calling has just stepped out of the office—you're not cut out for this type of work.

Annual reports are put together by highly specialized design firms. Our personal experience has been that they look at photographs more as a means to an end—delivering the corporate message—rather than as an integral part of the design. Because of this, Al finds it difficult to combine his style of shooting with their style of working. His shots are specifically designed by in-camera cropping and it's disheartening to find the work that you've spent weeks shooting insensitively cropped to fit their preconceived format. As he puts it: "I do my thing and then they do theirs. In the end, their point of view is all that matters."

In addition, there is less collaboration between the art director and the photographer on an annual report. You'll meet with the art director twice—once when you receive the assignment and a second time when you deliver the job. They don't come on site with you and many times have never been where you're going. Because of this, their expectations can be unrealistic.

The input before a shoot usually involves the "feel" that they're looking for and how they want to position themselves in the final layout. It helps to know something about what you're shooting and since the work is always last minute, there's very little time left for

CORPORATE PHOTOGRAPHY

any research. Al asks questions constantly when he is doing this kind of work: "What's this used for? What does it do? How does it work?" That way he can get ideas for shots along the way and hopefully construct some of his own setups.

From Al's point of view, it's preferable to work with the advertising agencies who handle corporate campaigns. These art directors work from concepts, which are less restrictive than annual-report layout and allow more room for experimentation. The art director will usually come with you on the shoot; he lives with you during the most creative part of the process; and you work together to create from the environment at hand. An advertising art director is therefore better able to understand through first-hand experience why you came back with the shots you did—for better or for worse.

The only way to learn enough to become adept at corporate photography is to get out there and start shooting. When you are just starting out you will have to give 150 percent of your energy and concentration to your work, because it's all new and unknown. Study annual reports and read books related to annual-report shooting. Ask questions of fellow photographers and take specialized workshops. But even then, you can really only be just so prepared for the unexpected; hands-on experience is the best way to learn.

The first step in getting jobs is to make sure you have your portfolio together. This means having a good representation of your work collected in a presentable form. You can show your work as chromes or prints, but your portfolio must reflect the wide range of photographic ability required by the field.

Next, get a list of design firms and corporations who hire photographers directly. Call any of the photographic trade annuals, such as *American Showcase* and *The Black Book*, and find out if they sell their mailing lists—most of them do. Contact the firms listed and find out who among their personnel you should approach with your portfolio.

You'll have to be persistent. As with other fields of photography, the competition for corporate work is tight and it's getting harder and harder to see the buyers. The budgets are getting tighter, too. To succeed you must be as good at promoting yourself and running the day-to-day business as you are at being a photographer.

Organization is the key to the well-oiled corporation, and the same is true of corporate photography. Don't forget that you'll be running your business from the road, which can be very difficult and fraught with frustration. And the corporate season lasts for only part of the year; you'll have to consider how you're going to pay the bills for the other six months.

Corporate photography isn't all hardship. Sometimes the timetables are reasonable, and the constant challenges presented by the different situations can be rewarding. You might even get to take a ride in the corporate jet.

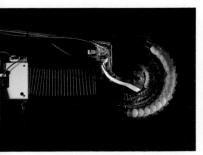

Fiber-Optics Imagery

Tom Van Steenbergh, the art director for ITT's advertising agency, noticed Al's page in *The Black Book* and called the studio to discuss an upcoming campaign. He was impressed with Al's technical knowledge and offered the assignment to photograph two developers of fiber-optic cable with their products. These shots would run as corporate ads in trade publications and, as is most often the case with corporate advertising, were meant to project the image of ITT as much as the product being featured.

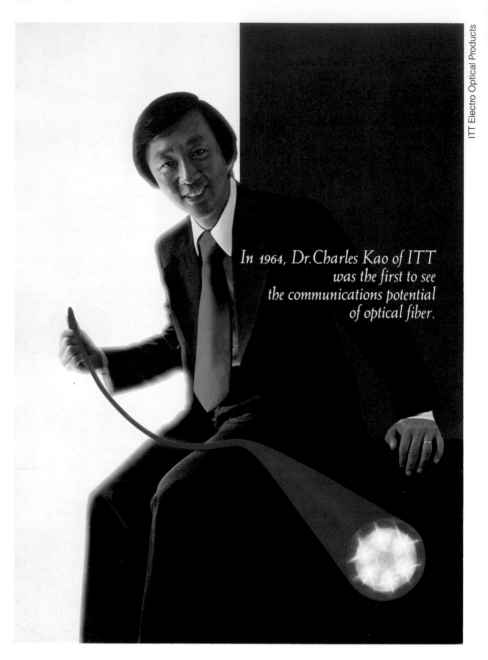

ITT Electro Optical Products

In 1964, Dr. Charles Kao of ITT was the first to see the communications potential of optical fiber.

Retouching is one of the greatest techniques at a photographer's disposal; it can save thousands of dollars or give life to an otherwise dull job. But like any other tool, retouching has its time and place and should be considered only as a pre-production solution to otherwise unsolvable problems. The decision to work with a retoucher should be made in advance so that you know exactly what you're working with. You have to pre-plan the different sections you will be shooting and know how they will fit together. Unplanned retouching is used either to patch up a job with problems or fix the shoot that turned out differently than anticipated.

When retouching becomes a shortcut in the production of a photograph, it is being misused. It is then merely an excuse for not going through the full creative process, which could destroy the possibility of coming up with something even better than the original layout. Some of my best shots have been the result of trial and error, and clients can cheat themselves out of good photography by being too cautious or trying to save money with retouching.

It doesn't usually cost that much to go the distance, or to try something different—and you might just come up with a far superior result. In fact, retouching is very expensive and only rarely is it cheaper than coming up with a photographic solution.

When Tom came to me with the concept for these advertisements, re-touching made an impossible situation a reality. He didn't want me to simply photograph a boring set of portraits of the men with their product. These advertisements dealt with high technology, so we decided to add a little magic to the shots.

A roll of extra-wide, white seamless was used as the background and floor of the set, with a smaller piece of black seamless moved in to add interest to the background and provide better contrast for the optical fiber, *which would be stripped in later.*

Dr. Kao was seated on a stack of "apple boxes," which is a term used by the movie industry to describe specially constructed, heavy-duty boxes used to "cheat" the height of people or props. I used black velvet to cover the boxes because I wanted a very deep black. The nap of the fabric causes it to absorb more light than seamless paper (black seamless will bounce light and turn slightly gray because of the surface sheen).

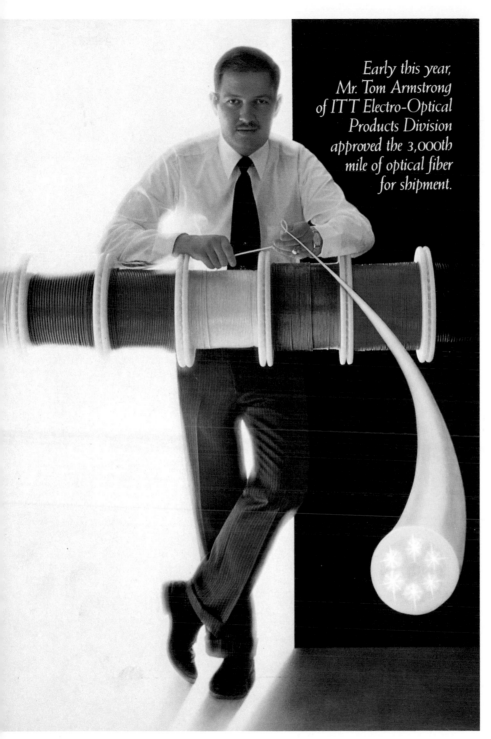

Early this year,
Mr. Tom Armstrong
of ITT Electro-Optical
Products Division
approved the 3,000th
mile of optical fiber
for shipment.

Dr. Kao held a plain-white, fiber-optic cord and was lit from the side with a 1200-watt-second Balcar soft box with one strobe head. Two 2400-watt-second Balcar bank lights with four strobe heads lit the white seamless and white fill cards were used to even out the dark spots. The setup for Mr. Armstrong was the same, except that he was photographed leaning on spools of fiber cord that were mounted on a rod and propped with saw horses out of camera range.

I rarely use a fog filter, but I did in both these photographs. I wanted to open up the shadow areas and add a little glow to the lighting. Both shots were taken on the same day with a Nikkor 55mm F3.5 lens at f/8 on Koda-chrome 25.

The pieces of optical fiber actually shown in the ads were photographed separately and stripped in later. I shot each piece as a close-up with a 20mm lens so that the perspective would make each appear to be coming out of the hand. I used an aperture of f/5.6 with a Bulb setting. The light output of the strobe was weakened because it was forced through the narrow opening of the tube, and I had to pop the strobe several times for each frame to get the proper exposure. This technique is frequently used in still-life work and is called "double popping"; since light works on a square relationship (mathematically speaking), in order to gain another f-stop of light you must square the light or double the number of strobe pops (1 pop, 2 pops, 4 pops, 8 pops, 16 pops, and so on). As long as the subject is locked off and can't move, there will be no problem with sharpness. This is a "field expedient" technique for increasing light power output without carrying larger, heavier, and more costly strobes.

Simulating Flight

Art director Tom Van Steenbergh (with whom we had worked on the ITT campaign) called Al again when another client, Westinghouse, needed a photograph of the U.S. Air Force's F-16 fighter plane. Westinghouse makes the parts used in the plane's construction and wanted to feature the finished product in their ads. The idea was to show the plane in flight, but aerial photography was out of the question because of the costs involved. Besides, Westinghouse could only guarantee the plane's availability for one hour. There would be no time for experimenting—everything had to be carefully planned out ahead of time.

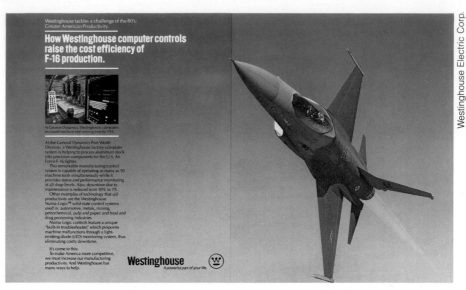

Westinghouse Electric Corp.

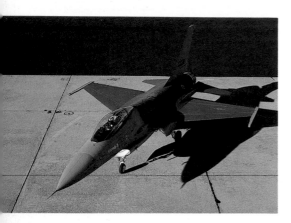

How do you make a plane look like it's flying when it's being photographed on the ground? Obviously, you use the talents of a good retoucher to remove the landing field and replace it with a sky. But how do you make it look like it's really in flight? I decided that this was a problem of perspective.

Because the F-16 would only be available for an hour, I had to pre-block the shot. We found a deserted landing field and hangar in Texas and rented a cherry-picker. I wanted to be able to photograph the plane from a high position. The Air Force was informed of the landing site and time for the shot.

I was up in the cherry-picker when the plane arrived. Communicating by walkie-talkie with my assistant on the ground, the plane was guided into the pre-planned position on the tarmac. The engines were shut down and the

pilot (who we used as a model) was told to stay in the cockpit with the canopy closed. Fortunately, he was a good sport—it was a very warm day and I'm sure the temperature in the cockpit was over 100°F.

We lit the front of the plane to simulate the angle of sunlight had the plane actually been in the air and I began to shoot. I was pretty sure of the perspective I wanted, but the cherry picker allowed me some movement for variations—and I shot as many photographs as I could in the one-hour limit, working with both a Nikkor 55mm F2.8 and an 85mm F2 lens. The photograph used was taken with the 55mm.

When the hour was up, I gave the pilot a wave. He started up the engines and taxied away for take-off. The art director had the plane's landing gear and the ground retouched out and added the smoke trails. In the final ad, the plane looks airborne.

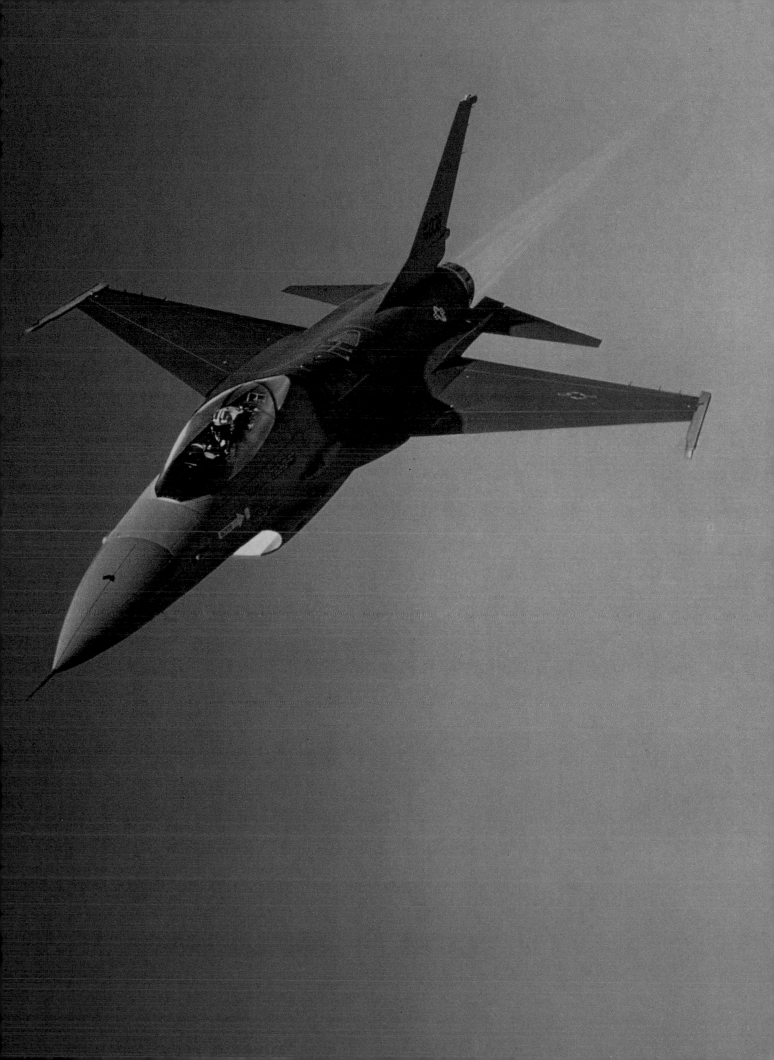

Aerobatic Photography

By now, Tom Van Steenbergh was convinced that Al could handle any assignment. He would call up the studio and say, "Let's shoot," many times not even asking, "How much?" Even under the best of circumstances, you shouldn't work without a written contract. Jobs such as these require a lot of pre-planning, so always make sure you're covered by a cancellation clause.

The assignment was to photograph a foreign oil tanker. Al immediately started doing research to find out the location of some major tanker ports and which ones would be convenient for photography. Shooting out of the United States can involve a lot of restrictions, so the right choice was important here. The island of Freeport, in the Bahamas, has a large off-shore tanker port. This became the most convenient choice, since Al knew a number of helicopter pilots based in Miami, Florida, whom he trusted and liked to work with.

Corporate photography often involves working from a helicopter. They provide a vantage point for photographing industrial sites, or off-shore locations such as this one, that can be reached in no other way. But even though it's common in this type of work, helicopter shooting is very dangerous work and can't be taken lightly.

Helicopters are like aerial tripods that can be maneuvered into dramatic and otherwise impossible shooting positions. However, aerial photography must be treated with extreme caution and requires extensive pre-planning. It can be very dangerous if you're careless.

Interview the pilot beforehand; you want a pilot who can take directions, but knows his limitations. You don't want a "hot-dogger" when your life is at stake. Most pilots are real pros—if they don't want to do something there is usually a good reason. Talk to them about the assignment at hand—they may offer solutions to some of the problems involved. Discuss the weather conditions with them as well; they'll be the best judge of how it will affect the shooting situation.

You should also talk to the pilot about his craft. Ask about its hovering capability and how many people can fly as passengers without interfering with his maneuverability. My preference over the years has come to be the Bell Jet Ranger. I put the art director in the front seat next to the pilot so that he has a good view of the total shooting area. I sit in the right rear, directly behind the pilot, so that we can both see what I'm shooting. My assistant sits in the rear, loads the cameras, and checks the light with a hand-held meter and a spot meter. I never fly with more than three passengers. Overloading can make it difficult for the pilot to maneuver and increases the level of danger.

Ask the pilot to bring along two extra headsets. Helicopters are very noisy and you can communicate with both the art director and the pilot more easily if you each have a headset.

I recommend that you buy and wear your own safety harness. I use a mountain climber's sit harness with a climbing rope, which I tie to the central strut of the helicopter. I allow enough slack so that I can lean out of the helicopter without falling completely out the door. If you allow too much slack and do fall out the door, you'll dangle there until the pilot can land. This is embarrassing, not to mention dangerous.

When shooting, you will be fighting the movement of the helicopter while trying to bracket your exposure. Due to wind, a helicopter can be very jumpy while hovering. Ask the pilot to continue to move the craft forward very, very slowly to knock off the vibrations and up-and-down movement. To help eliminate camera movement, avoid touching the aircraft as much as possible. Hold the camera with both hands—without touching the rest of your body—and keep the camera out of the slipstream (the air rushing by the open door). I have very steady hands from years of practice, and while I have shot film at 1/8th sec. from a helicopter, I feel much safer shooting at 1/250th sec. I have also worked with a gyro stabilizer, which is an eight-pound unit that attaches to your camera or a long lens. It has two small gyros that spin at 40,000 RPM to dampen any rapid movements, including your own.

I work with three cameras for aerial shooting. The lenses vary from an 8mm Fisheye to a 200mm. The best lenses to use are 35mm and 55mm. Use anything wider than a 28mm and you'll start having problems with rotors and skids appearing in the frame; any longer and you'll have serious problems with camera movement. Depth of field isn't all that important because your lens will probably be at infinity. If you use a Fisheye, you'll have to shoot with the camera facing straight down below the skids. I lay on the floor and hold the camera down with my arms fully extended. I can still see the image by using a sports prism. I try to shoot with Kodachrome 25, but sometimes I have to supplement with K64, or occasionally an even faster film, depending on weather conditions.

I always shoot aerials with a motor drive. Helicopter time is charged on an hourly rate, and they're very expensive, so I'll shoot anywhere from 20 to 40 rolls of film per hour. Plan on throwing away a lot of what you take, but do overshoot because your time will be limited.

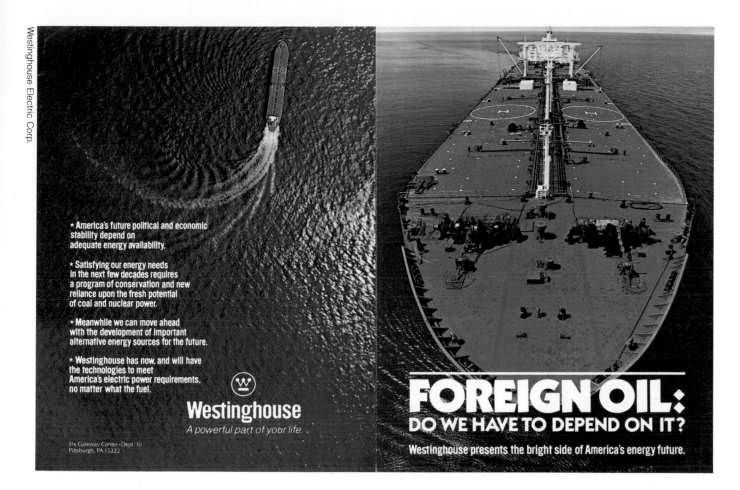

Westinghouse Electric Corp.

On a shoot like this one, you really can't work from a layout. Not even the art director knows exactly what to expect. Here, I was working from rough sketches that Tom had made, some of them done just a few minutes before I started shooting. He had a pretty good idea of what he wanted and we would flesh out the concepts as we went along.

It's a risky business and only a confident art director can work this way. But if you establish a good working relationship, many times you begin to think almost as one person and work off each other's suggestions.

The first photograph of the tanker was for the cover of the piece. I wanted to give the ship a mighty, massive look, so we hovered 12-feet in front of and 20-feet above the bow. I used a Nikkor 24mm F2.8 lens to get the right perspective.

Working with such large subjects is difficult; you can't just pick them up and place them in the right spot. You have to think of them as very large still lifes and approach them in much the same way as far as lighting and perspective. That's why I like to work from helicopters—I can view large subjects and figure out the position from which I want to photograph the subject and then move myself into the right vantage point.

We took a second shot of the same tanker from a higher altitude (1500 ft.) I knew that the photograph would need something to make it more dramatic. Tankers move so slowly they don't create much of a wake. So the next day I hired a 30-foot cruiser to provide the needed current and shot it from the air. All Tom had to do was strip the smaller boat's wake in behind the tanker for the final ad.

Double Exposing for Design

Double exposures, double images, and sandwiches are all words that describe methods of taking two separate photographic images and combining them to make one. This brochure for Puch Bicycle is a good example of how this technique can be used as an effective design tool. Whether you create the double image inside or out of the camera, careful pre-planning is necessary to achieve successful results. In this case Puch Bicycle supplied us with an unusually detailed mock-up of the brochure they wanted, which Al followed very closely to plan his shots.

Steyr Daimler Puch, New York

The choice of combining two images inside or out of the camera depends pretty much on your subject matter. If you are working with a light background, you should shoot each image separately, combine and then rephotograph them. Photographs with dark background can be combined on the same film, inside the camera.

Sandwiching and double exposure both require lots of practice before you become accomplished at either technique. It's a matter of getting used to the type of subject, the effects of light and dark combinations, and the positioning of subjects within the frame that will start to give you a feel for what you are doing and how far you can go. Either technique can be very simple or very complex. More complicated situations may require a pin-registered camera (which costs about $3,000), pin-registered masks, and a pin-registered duplicating machine to effect very complicated multi-image compositions. At this point it might be better to go to stripping and retouching to accomplish the task.

In doing multiple-image work, I try to keep the different elements as simple and as graphic as possible. If the elements get too complicated they can clutter the frame and the finished product won't "read" correctly. When I'm working on a complicated assignment, I usually shoot a "pre-light" day. This is a dry run before the actual job so that I can work out any problems without the client being present.

Many photographers feel that this type of work is best done with large-format systems, such as 2¼"-square, 4 × 5, or 8 × 10 cameras, but I've created them successfully on 35mm. No matter what format you use, purchase an "E" screen (which was designed for use by architectural photographers) to fit directly onto the ground glass of the camera. The "E" screen is etched with vertical and horizontal lines, forming a grid which is then placed between the mirror and prism of the camera. On large-format cameras, you have ready access to the grid and can sketch directly on the surface with a grease pencil. It's more difficult to do this with 35mm because of the small size, so it's best to reproduce the grid on paper. The point of the grid is to allow you to outline where each subject falls within the frame.

For light backgrounds, plan out the placement of each subject on the grid and set up the first photograph. Once you have the subject in place, "lock off the camera," making sure that there's no chance of accidental movement. You'll want a fairly transparent background in each of the two shots, so overexpose them.

Follow the same procedure for photographing the second subject, checking the alignment carefully on the grid. After the two images are processed, take them out of the mounts, align them according to your original sketch, and rephotograph them as a sandwiched image.

Photographs with dark backgrounds can be combined on a single piece of film inside the camera, but the process begins the same way. You'll still need the "E" screen and the graph on paper to register the two images. You'll also have to shoot a lot more film by double exposing in the camera; depending on the difficulty of lining up your subjects, you may shoot anywhere from ten to twenty rolls.

Load the film in the camera and, with the back still open, advance it to the first exposure. Mark a line on the film where the sprockets project through the sprocket holes. Close the camera back and proceed to photograph your first subject. Rewind the film when you're done, but be careful not to wind it all the way back into the cannister. When you hear the film leave the sprocket holes, you can stop rewinding and open the back of the camera. Line your film up according to the mark you made for the first exposure, close the back of the camera, position the second subject in the frame according to your grid, and lock off the camera. Expose and develop, and you've got your double exposure. Your registration may not be perfect, but it should only be off by about a millimeter.

As you can see by the layouts shown here, the assignment for Puch was fairly well planned out and completely designed around the double exposures.

GO FOR THE GOLD

You have the knowledge.
The experience. The training.
You're as wily as a fox and
you want to win. It's you
and your bicycle.
Two finely tuned machines.
The perfect meld of muscle and
metal. Together, you are as one.
And you're ready to go for it.
The quiet is almost eerie.
The crowd is silent.
Only the whirr of wheels can be
heard as you cruise with the
lead group. You wait. You cal-
culate your sprint to a fraction
of a second. And then it's time.
You break away with a surge
of speed. Your bicycle responds
as if it knew before you.
The crowd at first is stunned.
The calm becomes frenzy and
it sets the pack afire.
Bicycles shoot forward. You
have to hold your lead
just a few meters more.
The crowd goes crazy
as you feel the whoosh of the
checkered flag on your back.
And you have won. You've won
the most exciting, most demanding
of all sports. You are,
at last, a World Class Racer.

ULTIMA
FRAME SIZES: 53, 55, 57, 59, 61 cm.
HEADTUBE ANGLE: 74°
WHEELBASE: 39.5"
FRAME MATERIAL: Reyn...
FORK MATERIAL: Rey...
with semi-sloping crow...
COLORS: Pearl ...
LUGS: Boot...
DROPOU...
RIMS...
SP...

BR...
CRAN...
CHAINR...
FREEWHEE...
CHAIN: Regina ...
SADDLE: Corsaire ...
SEAT POST: Campagn...
DERAILLEURS: Campagn...
Rear: Record
SHIFT LEVERS: Campagnolo Recor...
PEDALS: Campagnolo Record
WEIGHT: 20.5 lbs. (57 cm. frame)

WORLD CLASS WHEELS

The Austro Daimler by Puch has
been chosen by four members of
the U.S. Olympic Team and five
members of the U.S. National Team.
It is a production line bicycle
that can be purchased from
your dealer.

Steyr Daimler Puch, New York

e L'Heure

d. Sm.-Flange, Q.R.

Clement Strada 66
RS: Cinelli Giro D'Italia
nelli
ES: Campagnolo Super Record
RANKS: Campagnolo Super Record, Titanium bottom
 bracket axle
 CHAINRINGS: 42/52
 FREEWHEEL: Regina Oro 14/22
 CHAIN: Regina Oro
 SADDLE: Unicanitor
 SEAT POST: Campagnolo Super Record
 DERAILLEURS: Campagnolo Front: Super Record
 Rear: Super Record
 SHIFT LEVERS: Campagnolo Super Record downtube
 PEDALS: Campagnolo Super Record with Titanium axles
 WEIGHT: 20 lbs. (57 cm. frame)

SUPERLEICHT

FRAME SIZES: 53, 55, 57, 59, 61 cm.
HEADTUBE ANGLE: 74°
WHEELBASE: 39.5"
FRAME MATERIAL: Reynolds 531 Double Butted
FORK MATERIAL: Reynolds 531 Double Butted
 with semi-sloping crown and Campagnolo fork tips
COLORS: Champagne
LUGS: Bocama Super Luxury
DROPOUTS: Campagnolo Record
S: Fiamme Red Label
S: Chromed
mpagnolo Record Strada Sm.-Flange,
ar
Clement Condor
lli

ada

Streamlining a Picture Series

This assignment for an advertisement for Alucobond, a manufacturer of building siding, provided Al with a small problem of logistics: the two architects and each of the buildings to be photographed were located in four different parts of the country. Stripping four different images together would not be difficult, but Al had to pre-plan each shot so that the dissimilarity of the individual situations would not be jarring to the eye.

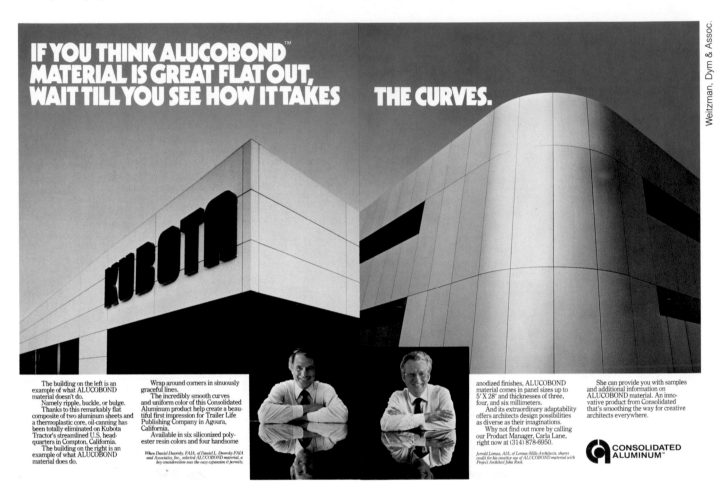

IF YOU THINK ALUCOBOND™ MATERIAL IS GREAT FLAT OUT, WAIT TILL YOU SEE HOW IT TAKES THE CURVES.

The building on the left is an example of what ALUCOBOND material doesn't do.
Namely ripple, buckle, or bulge.
Thanks to this remarkably flat composite of two aluminum sheets and a thermoplastic core, oil-canning has been totally eliminated on Kubota Tractor's streamlined U.S. headquarters in Compton, California.
The building on the right is an example of what ALUCOBOND material does do.

Wrap around corners in sinuously graceful lines.
The incredibly smooth curves and uniform color of this Consolidated Aluminum product help create a beautiful first impression for Trailer Life Publishing Company in Agoura, California.
Available in six siliconized polyester resin colors and four handsome

When Daniel Dworsky, FAIA, of Daniel L. Dworsky FAIA and Associates, Inc., selected ALUCOBOND material, a key consideration was the easy expansion it permits.

anodized finishes, ALUCOBOND material comes in panel sizes up to 5′ X 28′ and thicknesses of three, four, and six millimeters.
And its extraordinary adaptability offers architects design possibilities as diverse as their imaginations.
Why not find out more by calling our Product Manager, Carla Lane, right now at (314) 878-6950.

Jerrold Lomax, AIA, of Lomax-Mills Architects, shares credit for his creative use of ALUCOBOND material with Project Architect John Rock.

She can provide you with samples and additional information on ALUCOBOND material. An innovative product from Consolidated that's smoothing the way for creative architects everywhere.

CONSOLIDATED ALUMINUM™

Weitzman, Dym & Assoc.

I wanted each photograph to look as if it were taken at the same time and place as the others, even though it was obvious that they weren't. So I tried to make each shot as clean as possible, with no extraneous details.

I photographed the buildings with a Nikkor 28mm F3.5 PC lens. The PC stands for "perspective control," and is the equivalent of the rising front on a view camera. Since the lens rotates 360 degrees in its mount, it is usable left to right, or up and down. It allows you to level your camera and then raise the lens to take in more of the subject without tipping back the camera, which would cause a more dramatic perspective. These lenses have much larger coverage than the normal 35mm frame, which allows you to "crank up" the subject without any cut-off. By using this lens, I was able to eliminate useless and distracting foreground. I also arranged to shoot each building at the same time of day so that the light in the two photographs would be compatible.

I photographed the architects in their separate offices, but brought along my own "mini-set." I used a piece of black Plexiglas as a desk top for both men, and hung black velvet behind them to eliminate any background reflections in the Plexiglas. Both men were lit the same, with a Chimera soft box and side fill from a soft-white umbrella with a Balcar 1200-watt-second strobe.

Saying "Transportation"

The Mazda company hired Al to produce a series of slides illustrating non-engine powered transportation. The slides were to be used in an audio-visual presentation at a share-holders' meeting. Most of the photographs in the show were taken of planes air-to-air. This shot was an "extra," taken at the end of the day's shooting.

I was packing up to leave the site when I saw all the planes lined up for the night. Between the colors of the gliders and the angle of the light—I couldn't resist taking a few shots. This is still one of my favorite photographs; a print of it hangs in our living room. Mazda liked it too, and included it in the final show.

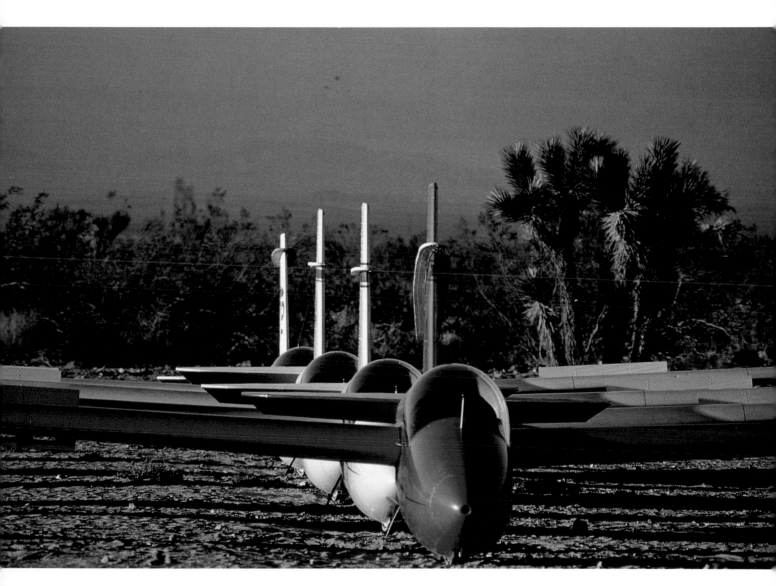

Adding Human Interest to High Tech

Most of the subjects that are photographed for corporate work are not pretty. You really have to keep your eye open for opportunities to make an industrial subject look more attractive and present a good image for the company that's hired you, which means giving free rein to your imagination. These photographs, taken for a Florida Gas annual report and AT&T, are a good example of creativity in such situations.

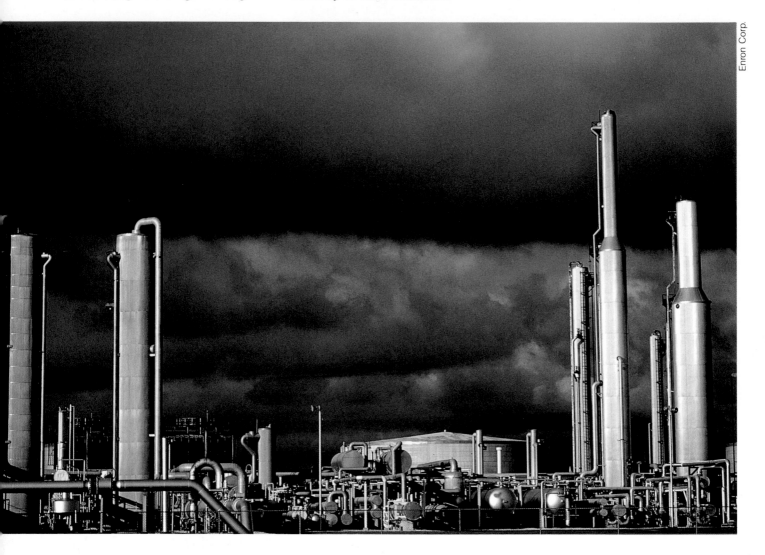

Enron Corp.

Very often, industrial sites are "messy"; there's work going on when you arrive and you can't really expect the people to stop everything and clean up just for you.

On a normal shoot, I'd call it a weather day when clouds like this begin to roll in. However, for this assignment, the clouds were a real stroke of luck. The contrast in the lighting and the ominous backdrop of clouds made an otherwise boring shot really dramatic.

I'll always try to find something *attractive about an area; many times the actual mechanics of the various structures can lead to interesting design solutions. Here, I really liked the lines formed by the gas pipes. I asked a worker to pose on top of them and shot him from the ground below, exposing for the sky. The pipes definitely said "Florida Gas" and the worker's position implied that he was "on top of things." This is corporate photography in its most perfect form—projecting reality and a subtly positive company image without being obvious about either.*

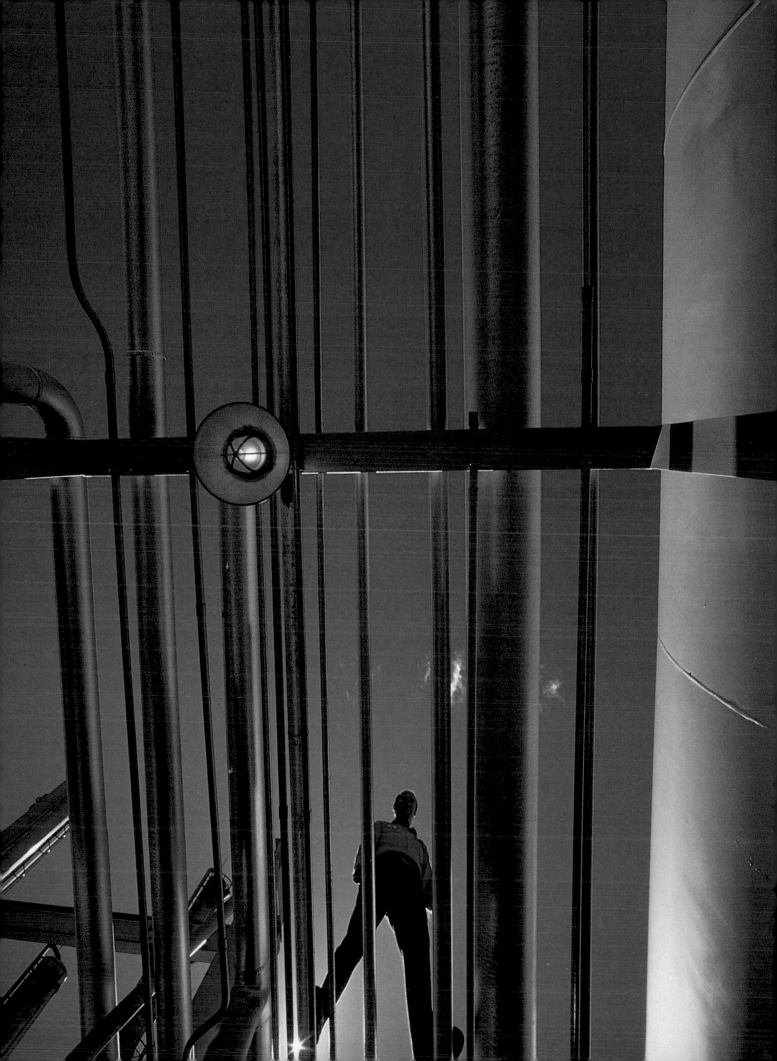

Enron Corp.

This panel of wires and circuits presented a good opportunity for some interesting design work. Had I just photographed the scene as a wall of wire, it would have created interesting patterns, but adding a technician to the photograph made this a picture that really worked for the client. I lit the background with warm light, using a color temperature meter to balance it with the foreground. I used a Nikkor 24mm F2 lens at f/5.6 with an exposure of 1 sec. on a tripod with Kodachrome 25.

Grabbing an Opportunity

When you arrive at an industrial site, a company representative will usually take you on a tour of the area, pointing out things that they want photographed. Always keep it in mind to look for opportunities that will be interesting to you as a photographer, but the guide may have overlooked. This photograph is essentially a "grab" shot, noticed by Al when he was working on an industrial assignment at the Bauxite Docks in Jamaica.

I was photographing an entirely different subject when I looked over my shoulder and saw this shot, I grabbed my other camera, which had a Nikkor 200mm F4 lens on it, and started to shoot. I loved the angle of tension created between the rope and the worker. I was able to grab three frames before he changed position. In a minute, the image was gone. The shot is monochromatic, but I didn't use a filter. The red dust covered everything at the site, and everyone that worked there.

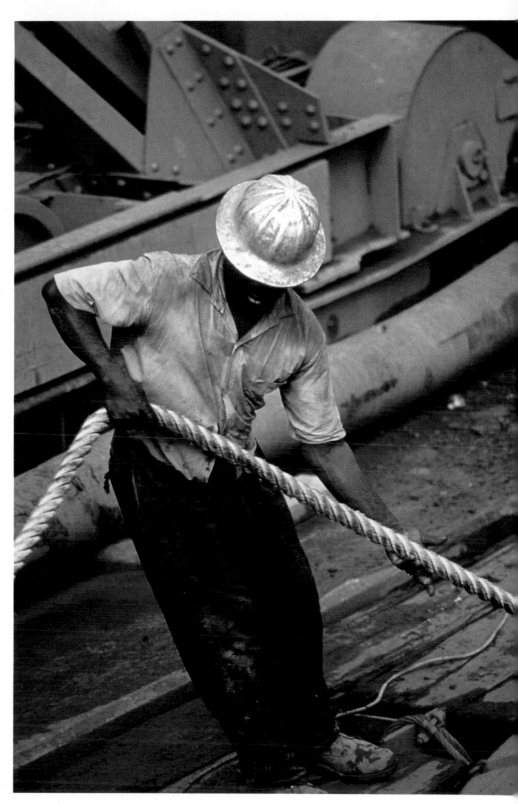

Improving a Location's Potential

Sometimes on an industrial site you can institute some control over your surroundings—if you're lucky, that is. In this series of photographs, taken for a five-page insert ad for Westinghouse, Al didn't have to improvise or make the best of what was there. The extra attention to detail really went a long way in projecting a strong company image.

Working with the art director's concept, I had a model-maker construct and stencil the wood crates to my specifications. This created a cleaner look—even though it was obviously a loading dock, I didn't want the site to look cluttered. It would have detracted from making a strong point with the image.

The lighting setup was difficult to plan because I had to match my foreground lighting to the natural light of dusk and the ship's lights. The latter two factors were givens and, depending on how much depth of field I needed to keep my area of sharpness, I lit the foreground accordingly. In this case, my aperture was set at f/8.

My main lights were strobes, which were supplemented with Lowel Tota lights to make the artificial light a little warmer. The headlights of my car added some last-minute fill, throwing the shadow of the bollard onto the crate in the foreground. A little pocket money for the ship's First Mate convinced him to turn the ship lights on for an hour.

Westinghouse Electric Corp.

"Made in USA."
Will it continue to be the sign of the world's foremost industrial power?

Westinghouse addresses a challenge of the 80's: Productivity.

These men don't normally work in uniform—they wear their own clothes. I wasn't really interested in photographing them as what would appear to be a snap-shot of a casual-looking group, but I couldn't come up with an interesting graphic at this site. I decided to work with the orange color of the tanks in the background, so I rented matching coveralls in the same orange for the workers and asked them to wear the dark blue helmets emblazoned with the company logo. This work site never looked so coordinated and I came away with a shot that pleased the client very much.

Section Three

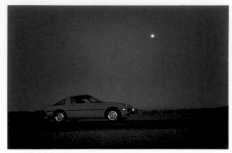

If corporate photography is the "meat and potatoes" of the industry, then advertising photography is the "champagne and caviar." The initial investment is much greater and the strategy for success more complicated, but the advertising photographer can earn anywhere from $1,500 to $10,000 per day.

Advertising assignments, with rare exceptions, come from advertising agencies, and although they may pay you "big bucks," you'll have to spend a lot of money to get their attention, hold it, and continue to impress them even after you have the job. This is the most competitive area of the industry, and the one in which the clients' loyalty can be the most fleeting.

A strong portfolio is only the beginning for advertising work. You'll need at least six well thought-out "books" to circulate among the different agencies if you're working in a major market like New York City. Your portfolio should be tailored to the market, showing how well you can solve problems—the client needs to see why he should hire you over someone else.

A good rep is also important in advertising. It takes a lot of calls and appointments to keep a career going, and your time is best spent shooting, not dialing the phone. An effective mail campaign is useful too. This keeps your name in front of the buyers' eyes on a regular basis.

Hopefully, this diligent work will pay off and you'll be asked to bid on a job. That's right—I said bid. Agencies usually ask three photographers to bid on each shoot and then they'll compare the estimates. Budgets are extremely important in the advertising business, but that doesn't necessarily mean that the lowest bid gets the job. If you've underbid the other two photographers by a substantial amount, the art director and the art buyer (who pays the bills) will want to know why. They don't want to have extra charges added on after the job's been assigned. It's not good to have a reputation for being a photographer who "low-ball's" a bid—at best, the overage in the final bill will get the agency in trouble with their client and they won't hire you again; at worst, you'll be asked to swallow the extra cost and it will be taken out of your fee.

The flexibility in your bid comes from the amount of creativity you use to produce ideas that bring the expense budget down and your decision on how much of a day rate you want to charge for the job. There are no hard-and-fast rules about day rates; each negotiation you do will be different. Look at the job and decide how badly you want the assignment, then figure out how much of your time and energy it will expend.

The price you charge will also depend on what kind of rights the agency is interested in buying. The rights to the photographs represent an agreement between you and the agency regarding how—and for how long—they are able to use the work in question. Usage fees will differ depending on whether the advertisement will run nationally, locally, on billboards, in magazines or newspapers, or as part of a "point-of-purchase" display. You should also qualify the length of time for use, which runs from the time the ad comes out to its cut-off date. Some agencies have policies regarding how much they will pay for certain rights and some don't, so you should always ask for this information before you make your bid. Personally, I always try to negotiate for unlimited usage and retain the copyright, but rights are an issue of great controversy these days, so I would recommend that you research the subject thoroughly and decide what's best for you.

You have to deal with a larger cast of characters when you shoot an advertising assignment. The art director is your key contact. He is responsible for coming up with the concept and picking the supplier (the photographer) who will help him execute it. He is ultimately responsible for the outcome of the assignment—the finished ad. If he is unhappy with your work, he can prevent you from getting any further work from his agency. In other words, politically speaking, this man or woman is very important to your future.

Generally speaking, art buyers are responsible for

ADVERTISING PHOTOGRAPHY

your billing and all other paperwork that will pass between you and the agency; this includes purchase orders, advance checks, and overage reports. The power of the art buyer differs from agency to agency. Most small agencies don't have art buyers, but if you are shooting for an agency that does have one, and the art director requests something that was not in the original specifications or budget, it is your responsibility to contact the art buyer to get approval for the extra expenditure. If you're on location, you can get approval from the account executive.

The account executive's role is similar to that of an ambassador to a foreign country: he is the agency's representative in charge of communication with the client. He, or she, will usually be present at shoots—especially if the client is in attendance. Normally, you will have no reason to deal extensively with either the account executive or the client, unless there are problems with the budget or the ad is off-base conceptually and requires major changes.

Everyone in the advertising industry speaks in terms of "concepts" and "marketing targets." The concept is the general idea behind the ad. For example, they may want to demonstrate that life can be fun if you drink their beer. A target market is the audience they want to reach, which may be young, 25- to 35-year-old "movers and shakers," or 35- to 55-year-old "belongers," women who value things that their friends have. Understanding these marketing categories will help immensely when you are purchasing props and wardrobe for your shot. It will direct you toward the kind of details that the audience will identify with.

Once you've received the advertising assignment, you'll be working from a layout, which is the art director's drawing of what is to be shot. Most of the time there is little latitude from layout to finished ad, because that same layout has been through many levels of corporate approval before you've been asked to bid for the job. These approvals come from both agency personnel and representatives of the client, and it can take as long as a year for one art director's concept to become a reality. The layout you receive may be new to you, but your art director may have spent the last six months revising it. You should be

Don't try to change the layout or concept of the ad just to make your job easier or to make the final shot more suited to your ideas or style of work. If you don't like the layout, you shouldn't have bid on the job. Al always tries to shoot the layout the way the art director wants it first—then he covers the assignment in his own style. More likely than not, Al's preference is picked up and used, but the art director is never made to feel that the issue was forced—everybody's self-respect remains intact.

Shooting to fit a layout is more difficult than simply going out to photograph on your own. Pre-planning is of the utmost importance here, because you'll usually only have one day to shoot per layout. And as for your style, well, that's often secondary to getting the job done on time and under budget. Hopefully an art director has hired you because of your style and he and you will have a sympathetic design sense. But just as often there will be those jobs that simply pay the bills.

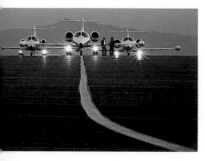

The Molson Golden Opportunity

Art Director Joe Loconto of the Dancer, Fitzgerald, Sample agency asked us to bid on a campaign for Molson Golden Ale. The resulting photographs, called "Tent" and "Beach," may look simple, but a lot of pre-planning and production went into each shot. Most of the details had to be worked out prior to giving the agency a reasonable estimate. We based the bid on shooting in Florida, because Al felt that the St. Petersburg area could provide locations in close proximity that would serve for both shots.

We received the assignment and Al left for Florida to scout locations. In the meantime, the staff in New York started tying up the loose ends. We had to have everything ready to show the art director and the client's representatives at a "pre-production" meeting.

A stylist was booked and briefed on the wardrobe and props needed for each shoot. She lined up everything that was needed, except for one major detail. Al and the art director had previously agreed that the tents used in the first shot should be yellow in the foreground and blue in the background. Al wanted to use his trademark hot colors, and Joe wanted the yellow of the tent to balance the still-life shot of the bottle of ale that would appear in the lower corner of the final advertisement. The stylist was stumped—she couldn't find tents of the right color anywhere.

Teamwork is very important on major jobs. If one person can't complete the task, someone else has to. You're judged by how you complete the work—agencies don't want to hear excuses. I started with the *Yellow Pages*, looking at the listings for tent manufacturers. Several were called and asked to make a yellow tent under special order. Not one would handle the job because it was too small an order. As a last resort, I asked one manufacturer if he knew of a tent designer. Needless to say, you learn a lot in this business—I was given the name of a "tent architect," who in turn gave me the name of his supplier for samples. The supplier was able to make us a yellow tent within two days, using one of

the tents our stylist had purchased as a pattern.

It took a lot of extra effort to find the right tent, but that is a stylist's job. Because she let us down by not following through, she won't work for our studio again. The extra attention is what sets you apart from other photographers, and can make a difference when you're bidding on the next job for a client.

We wouldn't be seeing the models' faces in either ad, so we felt it would be more economical to use local talent. I called an agency in Orlando and asked them to send some Polaroids up to New York in time for the client to approve them at the pre-production meeting.

With that taken care of, I was down to the last two details. A meeting was set up with Richard Townsend, a very good model-maker. He was given the layout for "Beach," and we discussed his making a cookie-cutter type mold, in the shape of a bottle of Molson, that could be laid down on the sand to

"A Molson! You really know how to welcome a lady to the neighborhood."

Molson Makes It Golden

80

look as if the figure had been drawn by hand. After quite a bit of discussion, it became clear that any sort of mold was going to be more trouble than it was worth. I asked Richard how he felt about coming to the shoot and actually drawing the bottle on the sand. It turned out to be a great solution and it would cost the same to bring him with us as it would to pay him for making the model. I wouldn't be over budget.

One last detail and we would be ready for our pre-production meet-ing. Prior to his going to Florida, Al had decided that the sky portion of "Tent" could not be shot in the same frame as the foreground. It would be best to shoot a painted backdrop in the studio and strip the two together. After looking through backdrop-painter Sarah Oliphant's catalog, we didn't find one that suited our purposes, and decided to have her paint us one from scratch. Joe sent her some tearsheets of skies that he liked and she worked from these.

Everything was ready and waiting when Al called from Florida to say that, while he was very happy with the sites he had found for the "Tent" shoot, he wasn't pleased with the "Beach" locations. He was moving on to try the Bahamas. There he found exactly what he wanted: a very wide beach with hard-packed sand and jutting land line. Happy at last, he flew back to New York to present his location recommendations at the pre-production meeting.

Everything was approved—props, wardrobe—we even convinced them to let us shoot "Beach" in the Bahamas. The only thing left undone was approval of the models—the Polaroids hadn't arrived from Miami. But there was still time to nail that down; in fact, it was agreed that Al and Joe would approve the models in person when they were down in Florida for the "Tent" shoot.

"Well, now that you've drawn my attention..."

Molson Makes It Golden.

Joe Loconto on Location Shooting

I generally like to talk to the photographer just before the shoot begins. I want to pace it out with him and make sure we're on the same wavelength. I know the feeling that I'm after, but once I'm convinced that we're "in sync," I back off and let him do his thing. I don't want to have to tell any photographer how to get there from here.

Photographers need their space—they need room to think and work. Everyone is nervous on a shoot. The client is spending money and they think the shot should be done by the time the photographer clicks off the second frame. They need assurance. Aside from designing the layout, I feel my job is also to serve as the conduit between the client, the account executive, and the photographer. The more informed everyone is, the better—and smoother—the shoot goes.

The Molson Golden Opportunity

If there's time in the schedule, and I feel the location site is crucial to the success of the picture, I'll do my own location scouting. For a third party to work strictly from my ideas and the art director's layout can be limiting—it's hard for someone else to make judgement calls for me. What happens if he stumbles onto what I would consider to be a great location, but he overlooks it because it doesn't meet the specifications I gave him?

I, on the other hand, know best what I want and am able to make snap judgements there on the scene. A lot of magical "accidents" can happen that could never have been planned for. That's the beauty of location shooting—you get to work with nature as much as possible. Of course, I still have to take Polaroid tests of the spot and convince the art director (among others) that it will work, but at least the option won't have been overlooked.

When scouting a location I carry along very detailed maps of the area I intend to cover. I also bring along scissors, Scotch tape, file folders, and, of course, my Polaroid. Sometimes I'll shoot 35mm as a backup, but Polaroids work best for my purposes.

When I see a spot I think will work, I shoot a panorama of the site by standing in one position and shooting overlapping Polaroids covering an area of about 90 to 100 degrees surrounding the focal point. Then I cut off the borders of the Polaroids and overlap them with matching horizon lines. These are taped down on the file folder. I take readings of where the sun comes up and sets and mark those on the folder as well, along with any other information that might be important.

For instance, I will list the accessibility of the site to and from roads, the availability of power sources, and anything else that will be needed to produce the shot at this location. I'll note convenient hotels, restaurants, and gas stations—especially if the area is remote.

Finally, I research who owns the property and make a note of their name and telephone number. I then contact them for tentative permission, finding out up-front what kind of fee

they would charge, if any, and what other arrangements must be made to secure permission to shoot on their land. I always get a property release signed before I shoot.

In advertising, it is the photographer's responsibility to carry insurance coverage for the shoot, so we have a one-million dollar liability policy. In some cases (especially those involving city, state, or national parks) proof of coverage is requested. We then simply call our agent and he supplies a certificate of coverage.

All this information goes on the file folder. Even if I don't use the location this time around, the folder gets labeled and filed away as a possibility for a future assignment.

Even though we had completed a lot of pre-production work on both the "Tent" and "Beach" shots, timing was critical and the schedule was tight—everything had to run like clockwork.

I went down to Florida to shoot "Tent" with art director Joe Loconto, the Molson account executive, a Molson representative, and two assistants in tow. Another assistant was sent ahead to the Bahamas to make all the arrangements for "Beach" so that we would be ready to shoot when we got there.

Among other things, he had to clear my equipment through customs, locate a crane (I needed a high per-

spective to shoot the drawing on the sand, and you just don't get that from a step ladder), and make arrangements for everything to be delivered to the beach in time for the shoot.

lo-tide -

Production Schedule

SUNDAY	MONDAY	TUESDAY	WEDNESDAY	THURSDAY	FRIDAY	SATURDAY
April	1 Bid Session (find out specifications on job)	2	3 Bids Due to Agency	4	5 Agency Approval of Estimate P.O. Issued	6
7	8 Make calls for casting session. Meet with stylist.	9 Cast Purchase Props Location Scout	10 Cast Location Scout	11 Approval of Cast & locations Purchase Wardrobe	12 Purchase Wardrobe	13
14	15 Pre-production meeting (discussion of shooting schedule, props + wardrobe selected)	16 Last minute production day - pre-light	17 Shoot	18 Shoot	19 Film to labs	20
21	22 Film edited and stamped	23 Film to Art Director Art Directors Approval	24 prop + wardrobe return day	25	26 Bill agency	27
28	29	30				

82

out 75 yds)

'MOLSON BEACH' 240° ↗
 sunset

hi-tide
(over cast)

Hi Tide - 10³⁰ am
Lo Tide - 4³⁰ pm

240° ↗
sunset

Sand - very hard-packed
30 min from hotel
road accessible

SILVER COVE

SUN AT 248
SET 6:10
2/24/85

SET AT 240° ↗

Cars: Hendz/Avis

HIGH TIDE 10:30 A.M.
LOW TIDE 4:30 P.M.

SHOT IN AFTERNOON

CRANE W/CAGE
$750/D-7 - CASH

Freeport Crane
driver: Frank

The Molson Golden Opportunity

Back in Florida, we began setting up for "Tent." My assistants began setting up the tents and power generators for the lights, while I set up the cameras. I wanted to shoot with three cameras simultaneously and put them in position on tripods. Once the cameras were in place, Joe and I could look through the viewfinders and communicate the proper positioning of the tents to the assistants through walkie-talkies. Once the positions of the tents were established, we could set up the lights.

I wanted to photograph the tents in the moment right after sunset. This would give me about twenty minutes of very nice, soft, detail light. We began setting up the shot at about 2:00 PM, with the idea that we then would be ready to go at 7:00 PM, which was sundown.

While we were on the site, I convinced Joe to make a slight change. I was originally supposed to photograph two people sitting in the yellow tent in the same frame as the other tent. However, I really didn't want to have something else to control; I'd be making very long exposures in a short space of time during which the light would be perfect. It would be easier—and safer—to shoot the silhouette of the models back in the studio with a painted backdrop. The figures could be stripped into the tent later. Joe agreed with me and we went ahead with the shoot.

I decided to use hot lights, rather than strobes, and put one 1000-watt, Lowel Tota-Light in each tent, each connected to a large rheostat, with which I would control the light output as the available light fell off. I ran several rolls of Polachrome through the cameras to work on the tent-light ratios, adjusting the lights with the rheostats.

Finally the sky was right and it was time to shoot. I was able to shoot ten rolls in about twenty minutes, constantly decreasing the light intensity of the tents as it got darker outside.

The Polachrome was processed and checked later that night at the hotel. The shot looked great and everyone was very happy. We could devote the next day to casting the "Beach" shoot and move the crew on to the Bahamas. The studio portion of "Tent" would be shot when we returned to New York.

Photo © Bruce Wodder

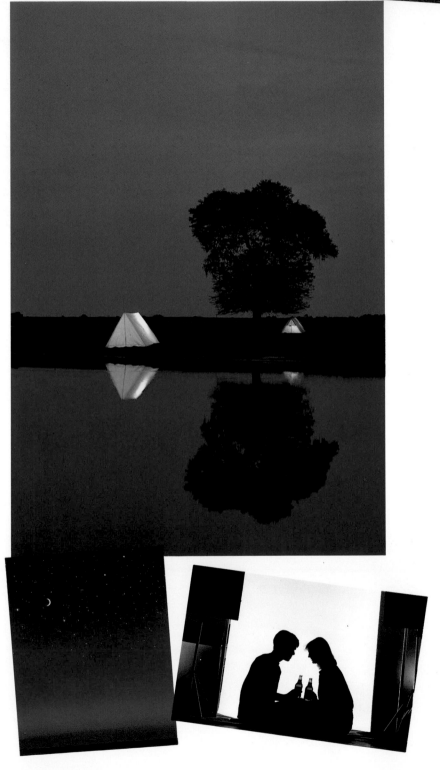

84

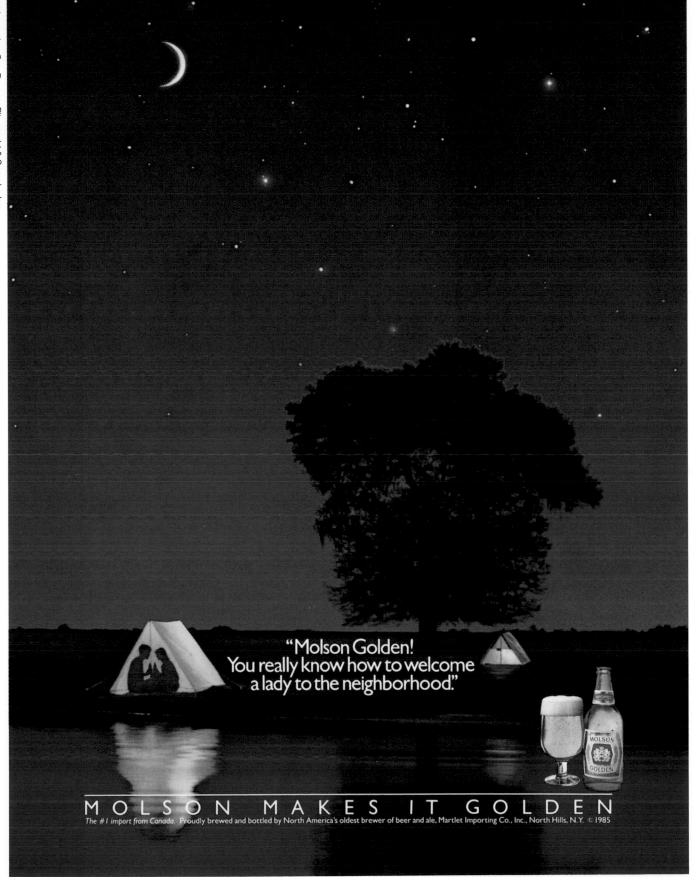

Martlett Importing Co., Dancer, Fitzgerald & Sample, Inc.

The Molson Golden Opportunity

The casting session in Orlando was a disaster—not one model was suitable. Al saved the day by arranging another casting session with an agency in Miami for later that afternoon. Joe and the Molson representative flew to Miami to book the models, while Al and the rest of the crew went on to the Bahamas to start working on "Beach."

Joe, the client, the models—and the model-maker—arrived in the Bahamas that evening. A production meeting was called and all of the details of the next day's shoot were coordinated. The production of this shot was well-choreographed, and nothing should have gone wrong. However, as you'll see, "Murphy's Law" prevailed.

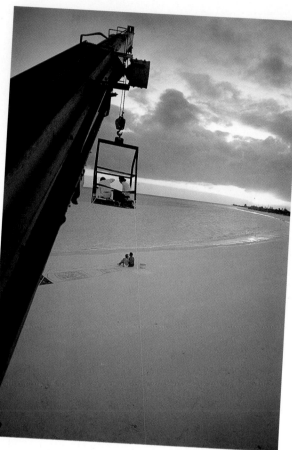

Photos © Bruce Wodder

At 7:00 AM the morning of the shoot, all three assistants were sent to the beach with rakes. As the tide receded, they were to walk out with it, raking the beach free of any debris. By 11:00 AM, the tide was all the way out and the crane had arrived with the driver, as planned.

Richard Townsend, the model-maker, originally tried walking on planks to the position where the bottle was to be drawn. However, the planks were making too much of a dent in the sand, so he worked on a large piece of cardboard instead. It took Richard an hour to draw the 12-foot bottle, so Joe and I climbed up in the crane to work out the perspective of the shot.

Richard completed the drawing and was sent further down the beach to draw a second one. He worked farther away from the surf line in case the tide started to turn and come in. We sent the stylist onto the beach via cardboard and directed her on the placement of the towels and props.

I set up two cameras, one with an 18mm lens and one with a 16mm Fisheye. I liked the way the Fisheye curved the horizon and Joe agreed; he felt it added just the right touch of romanticism to the scene. Both shots used in the production of the final ad were taken with the Fisheye.

We brought in the models and I had the crane positioned to a height of 14

feet. Looking through the viewfinder, I realized that the high angle of the camera was foreshortening the female model's body. To counteract this, I suggested she wear the large sun hat that we had brought down with the props. The hat also served to draw the eye to the couple, giving the female more presence. As an added bonus, the hat drew more attention to the line of copy in the final ad.

So now we were ready and I was just about to start shooting, when a huge bank of clouds moved into the frame, blocking out most of the sun. We sat and waited for the clouds to clear. In fact, we ended up waiting three hours. Then, just as the sun was getting ready to set, it peaked through the clouds. I had just enough time to bang off two rolls of film before the sun ducked down behind the clouds and disappeared.

I thought I had the shot I wanted—in fact I was almost positive, but no one wants to take a chance on "almost." We set up the shot again for safety the next day . . . and the next day . . . and the next day. For three consecutive days the sun refused to cooperate. Everyone was getting nervous and the forecast called for rain and clouds for another week.

I still had confidence in my first day's take, so I advised both Joe and the client to call it a wrap, send us home, and save the money. I think Joe was skeptical, but he trusted me. I appreciated this, since it was a difficult decision to make.

When Joe received the final film, he placed a darker, richer chrome of the sunset over a lighter chrome of the people on the beach and was ecstatic. Everything was going to work out great.

Martlett Importing Co., Dancer, Fitzgerald & Sample, Inc.

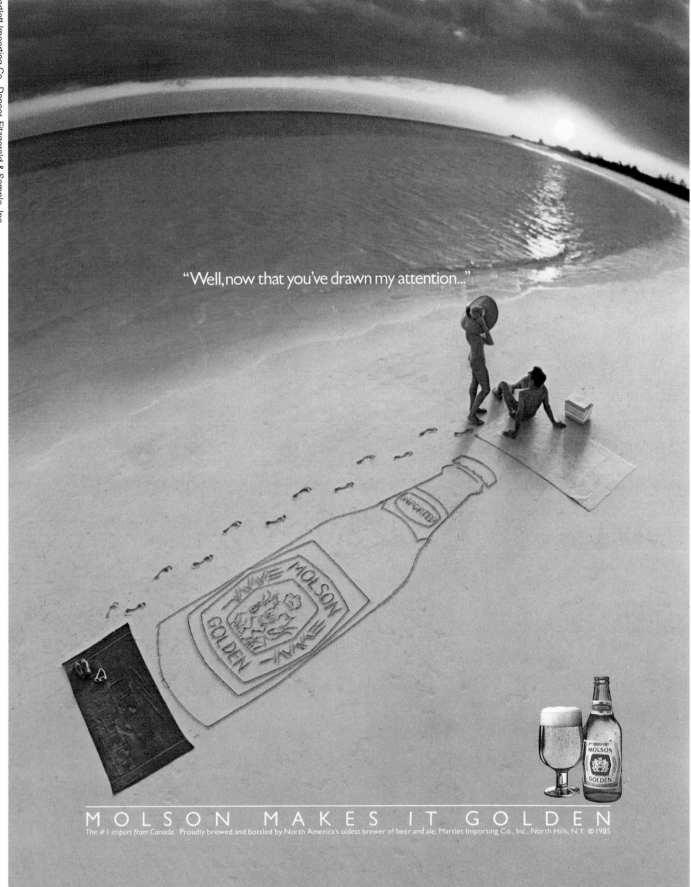

Six months after the first two Molson ads were shot, we were called into the Dancer, Fitzgerald, Sample offices to pick up the layout for a third ad, which would be called "Holiday." It was a great layout, calling for a very quaint house perched on a snowy hillside complete with evergreens. Vermont in February would have produced the ideal location for the shoot. But it wasn't February, it was June. Al and I looked at each other—where were we going to shoot this ad?

We went back to the studio and Al began checking with contacts in Chile, Alaska, and Australia for current weather conditions. For one reason or another, none of the location areas we tried would work; either there was no snow, or the snow line was too high, or there was snow but no house, or access to the site with all the props and gear required would be impossible. The dollar signs started ticking off in my head; I was afraid that when the agency heard how much this shot was going to cost they would kill the ad.

Then I had an idea. I approached Al and suggested that we shoot "Holiday" in the studio as a miniature set and that we could photograph the people, carriages, and horses live and strip all the elements together. Al wasn't keen on the idea. I explained to him that if we could pull it off, we'd be heroes, and we could use the entire Molson campaign as part of a promotion piece. I sketched out a rough drawing of a mailer, illustrating the first two ads shot on location with the third produced in the studio. Al began to warm up to the idea.

I convinced him further by doing research on model-makers. Joe Randel is well known for his special snow scenes, so I called and asked for his book. His miniature sets were incredible. Al was now convinced that this was the best way to shoot "Holiday." He would have much better control over the end results by working in the studio.

The problem now was to convince the agency that we could handle the job. Al had never photographed a miniature set, but we did have some strong examples of his still-life work.

"You can land on my roof anytime".

MOLSON MAKES IT GOLDEN

We set out for the agency, armed with samples of Al's still lifes, an estimate for the location shoot, an estimate for doing the job in the studio, and Joe Randel's book.

Art director Joe Loconto was skeptical. He trusted Al's work from the previous shoots, but wasn't sure if Al had the right temperament for a studio shot of such complexity. However, when he saw Al's still-life work and examples of Joe Randel's sets and listened to our reasons for a studio shot, he decided to give it a go. We were both excited and production started right away.

I immediately called Joe Randel and booked him for the job. He met with Al to discuss the specifications of the shoot, including what lens Al would be shooting with. Al selected a 20mm lens because it had good depth of field and provided the right spatial relationship for the scene. It would make the foreground look wide and expansive, with a very distant background to add to the set's illusion of reality. Joe used the same lens to determine the sizes of and distances between objects by looking through the lens while he was designing the set.

Since the lens would distort the objects on the set, Joe had to build "pre-distorted" pieces, which would then be corrected by the lens. For example, the house, which was to appear rectangular, was built as a trapezoid. But when you looked at the set through the lens, the house appeared to be correct. The trees were also built on an angle to the ground, but through the lens appeared to be at a right angle. The snow, by the way, was actually baking soda.

Photos © Bruce Wodder

Miniature Set

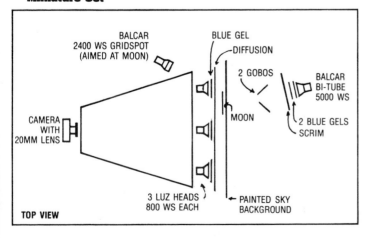

TOP VIEW

BALCAR
2400 WS GRIDSPOT
(AIMED AT MOON)

BLUE GEL

DIFFUSION

2 GOBOS

BALCAR
BI-TUBE
5000 WS

CAMERA
WITH
20MM LENS

MOON

2 BLUE GELS
SCRIM

3 LUZ HEADS
800 WS EACH

← PAINTED SKY
BACKGROUND

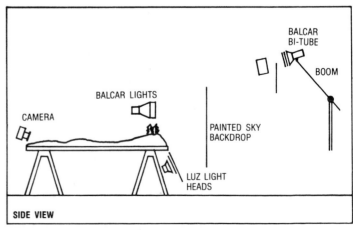

SIDE VIEW

BALCAR
BI-TUBE

BOOM

BALCAR LIGHTS

CAMERA

PAINTED SKY
BACKDROP

LUZ LIGHT
HEADS

I always prefer location shooting to studio work, but for this assignment it was far wiser to shoot it the way we did. Aside from all the logistical problems and the expense, imagine putting the horses in position and then getting them to stay that way while the snow was dusted clean of foot and hoof prints. Working in real snow would have made this impossible. In the studio I was able to control the environment, and I calculated every detail to make the shot work.

Prior to the first day of the shoot, I worked out a schematic of how the lights should be set up. We then allotted a day in the schedule just for actual placement of lights, working with the miniature set. I often allow for a "pre-light" day in the schedule. This gives me the time to set everything up, run lighting tests, do color tests, experiment and make adjustments at my own pace, without a client hovering around asking, "Why is it taking so long?".

Joe Randel had made miniature clay models of the horses, sleighs, and people. We placed these on the set and then set up the lights according to my schematic. This was an especially complicated procedure because I had to photograph the shadows with the miniature set. There wasn't a studio with a ceiling high enough to accommodate lights that would cast shadows from the live models, so we used the clay figures to throw the shadows on the miniature. The clay figures would be stripped out and replaced with the live models, horses, and sleighs for the final ad. In addition, I wanted lights to show in the windows of the house, and the moon had to be bright enough to throw light down the hillside. Everything had to be well thought out and carefully calculated for the setup to look real.

I kept testing the lighting setup with rolls of Polachrome, making adjustments until it all looked right. I then shot a couple of rolls of Kodachrome and sent them off to the lab for rush processing so that I could make a final judgement on the lighting.

The next day was a shoot day. I checked the Kodachrome and made some minor adjustments in the lighting. Even I had to admit the set was looking very good. I shot lots of Kodachrome and also photographed the set with Polachrome, which I deliberately overexposed by several f-stops. I would use the Polachrome as a guide the following day when shooting the live models in the sleighs. By placing the Polachrome over the ground glass of my camera, I could position the "live" set as closely as possible to the miniature, making life much easier for the retoucher.

We were now ready to photograph the "live" portion of the shot. An 18-foot scaffold was set up as a platform from which to shoot. The sleighs were brought in and positioned and the stylist got busy putting the bows and labels on the cases of Molson. She also hung bows of evergreen on the sleighs. Fake snow was then spread on the studio floor. The horses were kept waiting outside with their trainers. For obvious reasons, we didn't bring them in until the last minute.

The models were dressed and positioned in the sleighs and we began to set up the lighting. Great care had to be taken not to over-light the scene. It had to appear as if the scene were lit by moonlight, but the lighting still had to be bright enough to catch all the details that were important to the ad. We mounted carriage lamps on the sleighs and placed bare strobe tubes inside the lamps. This way I could "cheat" some light onto the models and still make it look believable. Lights were also positioned to subtly illuminate the cases of Molson. We balanced the lighting for the last time so that the shadow detail would look believable and—most importantly— match the contrast of the scene shot the day before.

Once the actual shooting began, the session went like a breeze. The end results of both shoots were stripped together and the final ad did indeed look very convincing.

Horse and Sleigh Set

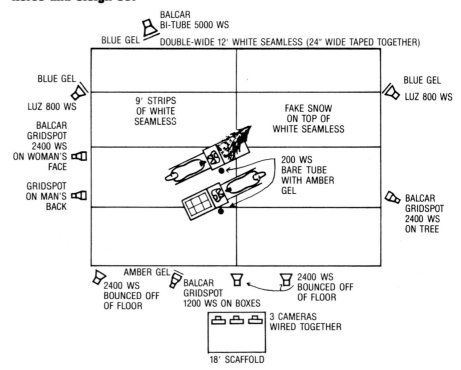

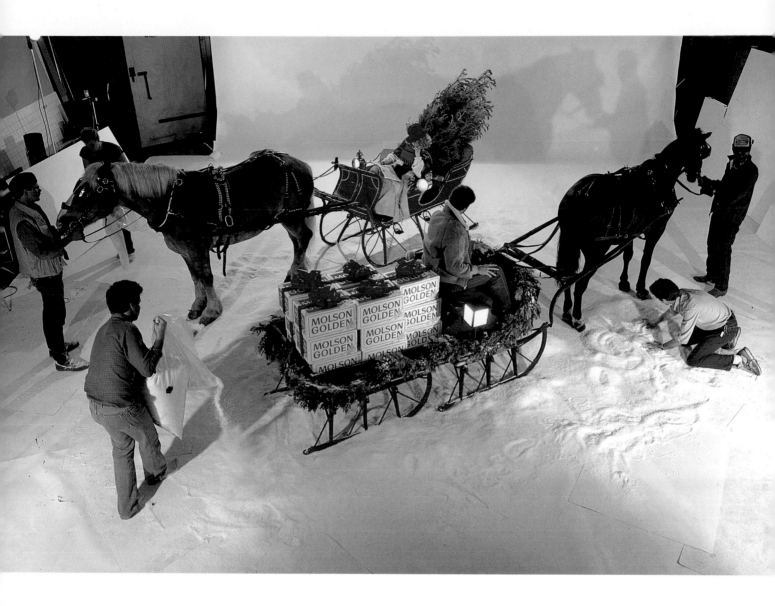

While the set was being built, I commissioned a stylist to purchase the wardrobe and to handle having the big bows made for the cases of Molson. I was to handle the rental of the sleighs and horses.

During the production, Joe Loconto informed me that the client wanted to be able to read the word "Molson" on the cases. I said, "No way, unless you change the lettering on the boxes." To prove the point, I took a Polaroid of a case of Molson to the scale of the layout and pasted it down on the drawing. Joe got the point immediately. He alerted the client and had labels made with much larger and bolder type that we could stick onto the existing boxes. We tested them again with the Polaroid and they worked perfectly.

The models were cast and fitted for wardrobe and a meeting was called so that the client could approve all the details. Everything went great, except for some discussion over the hat that the girl would be wearing in the shot. It was agreed that the stylist would get more hats in time for approval on "pre-lighting" day.

A large studio had been rented to accommodate the horses and sleighs and everything was ready to shoot.

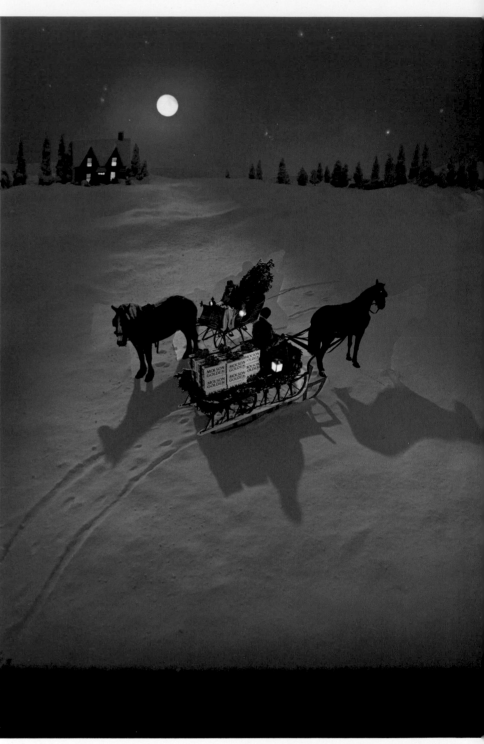

The shot of the miniature clay horses and sleigh (far left) was sandwiched together with the shot of the lifesized set in print production, resulting in the above unretouched print. Retouchers removed the mask lines around the horses and the image was ready for use in the final ad on the right.

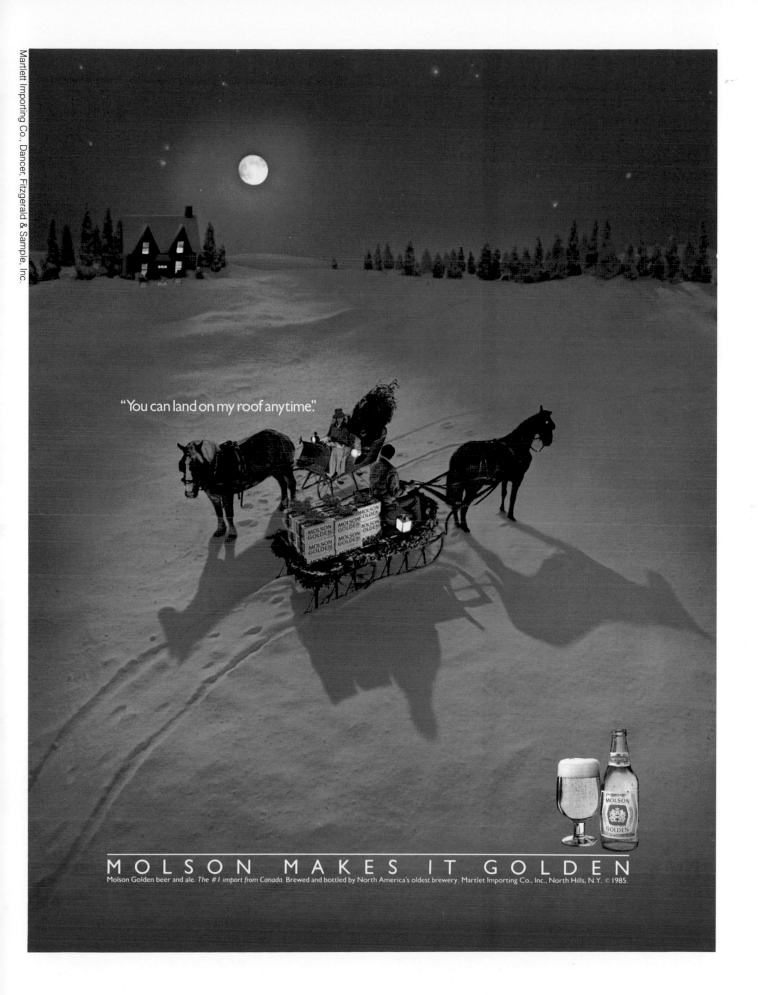

Martlett Importing Co., Dancer, Fitzgerald & Sample, Inc.

93

A Saab Story with a Happy Ending

Photographing cars can be relatively simple or it can involve a lot of production—it all depends on the circumstances surrounding the shoot. This campaign for Saab contained a little of both.

The first ad depended on finding the right location. We needed a background with the perfect combination of traffic lights, signs, and wires. Living in the New York area, we knew that New Jersey would provide the best choices. We ended up using two different locations. The first, which was shot for the background, proved to be too busy with traffic, so we shot the car by itself in a second, more isolated area.

The second ad for the Saab campaign required a lot of production. It was ironic; we were going to shoot a rain scene, but had to wait three days for it to stop raining so that we could make our own weather. Finally the conditions were right. As is usually the case, the shot took hours to set up and about one hour to photograph. A 6,000-gallon water truck was hired and arrived first thing the morning of the shoot. The assistants brought the rain towers, along with six 1-K (1,000-watt) hot lights and several power generators, in case the sun did not cooperate.

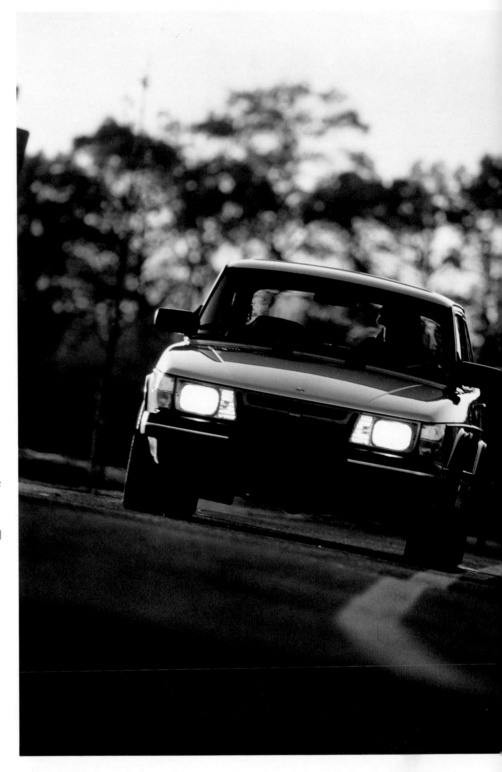

I set out with the art director and one assistant to do a final check on the location and determine the specifics for the shoot. We arrived late in the afternoon and it soon became obvious that the day's sunset was going to be a knock out. Rather than take a chance on nature repeating herself, I decided to go ahead and shoot the background right then and there. I sent the assistant to one side of the road to shoot with a 300mm lens, while I stood on the other side with a 400mm lens. We started shooting an hour before the sun set to get the warm glow in the sky and the silhouette of all the poles and wires.

We shot the car the next day on a deserted road with a great curvy yellow line painted on it. I made the most of the line by shooting from a low angle, setting the camera up on a "low-boy" tripod about three inches off the ground. I used a 400mm lens, and even though the car was not moving, it has the appearance of coming toward you. We worked strictly with available light, but used a silver reflector to pick up detail in the car's front grille.

The two shots were then stripped together by a retoucher for the final advertisement and as you can see from the instructions scribbled across these prints, more than one pair of hands worked on this image until it read exactly the way the art director wanted it.

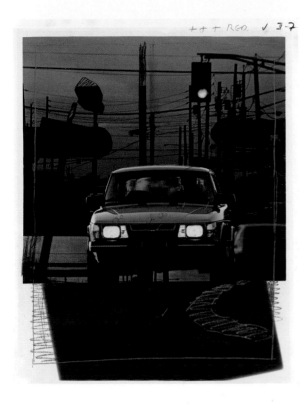

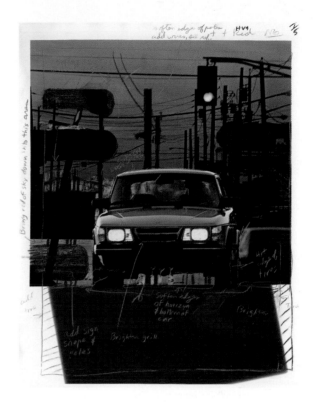

Ron Arnold, art director; Ally & Gargano, agency

DRIVE THE RIGHT CAR AND THIS TRIP IS NOT UNLIKE LE MANS.

A Le Mans of the mind, for speed is not all there is to the thrill of driving.

Given the right car, almost any particular moment can add to your enjoyment of life. (If that's a little too heavy, okay. But concede that it could be argued that merely idling in a finely tuned, finely engineered automobile can be a kick of ethereal proportions.)

So it's 8:31 in the morning. Let's examine the unbridled joy of driving a Saab at 35 miles per hour and lower.

8:31. A world class turn in front of the delicatessen made even more treacherous by the morning's rain. Front-wheel drive, rack-and-pinion steering, wide radial tires, Saab's aerodynamics. They all work to make the curve gentle and benign.

8:33. A full stop. Disc brakes on all four wheels are, of course, an old story. But it's a good old story.

8:33:07. Another full stop. This one unexpected. But made rapidly and unerringly. The car ahead with the "I brake for squirrels" bumper sticker really does

brake for squirrels.

8:36. Town road. The longest straightaway on the course. The 16-valve, intercooled, turbocharged engine, capable of doing 130 and more on a test track, reaches its mandated maximum of 35 mph and purrs nicely along at that speed.

8:38. McDonald's. A black coffee and an Egg McMuffin. The steam from the coffee goes out through the sunroof. Good option, that.

8:41. The gas station.

No sweat. Not with the kind of fuel efficiency' Saab gets despite its performance kick.

8:42. The bank. Car loan payment's due. No sweat there either. It could be a lot more having to pay off a BMW or Mercedes.

8:44. The Saab dealer. Contentment in knowing you have lots of dealers who stock lots of parts and train mechanics in every nook and nuance of the car.

8:45. Red light. Time to contemplate the safety that Saab's vaunted performance creates. Sure it's clear to the eye that Saab's construction provides passive safety. But the active safety of the handling, acceleration and sports car attributes require a long light to appreciate fully.

8:49. Stop at the lumber yard. Put the back seat down and fill the 56.5 cubic feet of cargo space with lots of nice redwood. Who needs a station wagon when you can have a sports sedan and a lot of room to carry junk besides?

8:55. 24 minutes at Le Mans. Finis.

 SAAB

The most intelligent cars ever built.

Effective January 1, 1986, Saab 900s range in price from $12,585 on the 900 3-door 5-speed to $20,085 on the 3-door 5-speed, 16 valve Turbo. Manufacturer's suggested retail prices. Not including taxes, license, freight, dealer charges or options. There are a limited number of Turbo models available with Saab's Exclusive Appointments Group, which includes leather upholstery, fog lights, and electric sunroof at additional cost.
*Saab 900 5-speed 16 valve Turbo. 20 EPA adjusted city mpg. 26 adjusted highway mpg. Use adjusted mpg for comparisons only. Mileage varies with speed, trip length and weather.

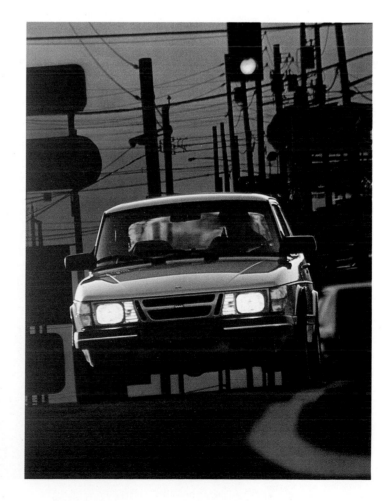

A Saab Story

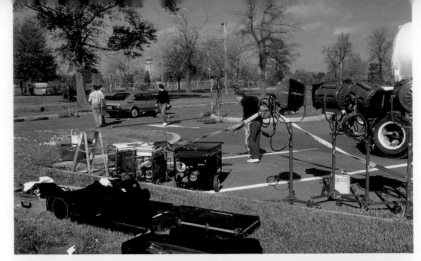

I wanted the car to be backlit to give the impression of a "spring shower." The sun was very bright that day so we didn't have to use the supplemental lights we had brought along. I had chosen to bring six HMIs (1200 watts), which are "hot" lights, rather than strobes. I normally use these tungsten lights with a tungsten-balanced film such as Kodachrome Type A, Ektachrome Tungsten or Fujichrome Tungsten. Sometimes I'll mix hot lights with strobes and use a longer exposure for a warmer effect.

The car was positioned so that the sun provided the backlighting. We used hydraulic jacks to raise the car off the ground, enabling the wheels to spin freely. The rain towers were erected and pipes were placed strategically around the front wheels to throw water on the tires and make "rooster tails," adding to the effect of a car in motion.

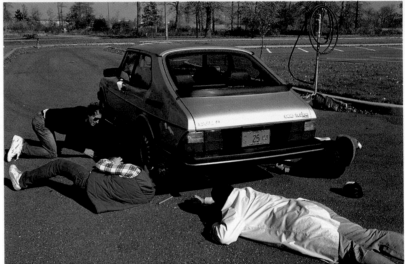

One assistant sat inside the car during the shoot and, using a walkie-talkie, I would instruct him when and how fast to rev the engine. This would turn the wheels and throw off streams of water. Another assistant was behind the car with a hose, spraying water to fill the open spaces.

I checked the effect with a lot of Polachrome, choosing long lenses to foreshorten the car and lose the background. Two more assistants held silver reflectors on the front of the car to add some fill light to the grille and compensate for the backlighting. We only had so much water left in the tanks and didn't want to waste time, so two cameras with different lenses were set up on tripods and fired simultaneously. I used both a Nikkor 300mm F4.5 and a Nikkor 400mm F5.6 to get a "loose" shot and a "tight" shot at the same time. By the time we were ready to shoot, there was only about an hour's worth of water left in the tank. Luckily, that was enough.

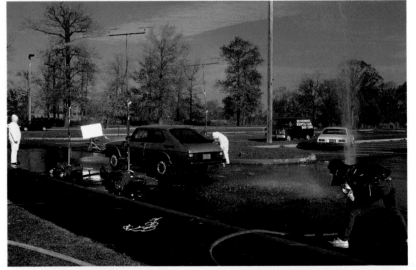

SAAB AS A MEANS OF TRANSPORTATION.

SAAB AS A MEANS OF EXPRESSION.

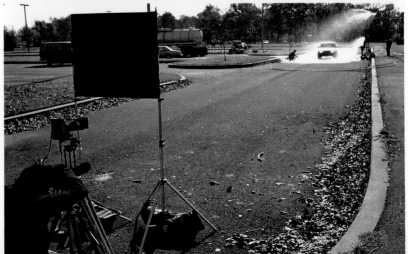

Ron Arnold, art director; Ally & Gargano, agency

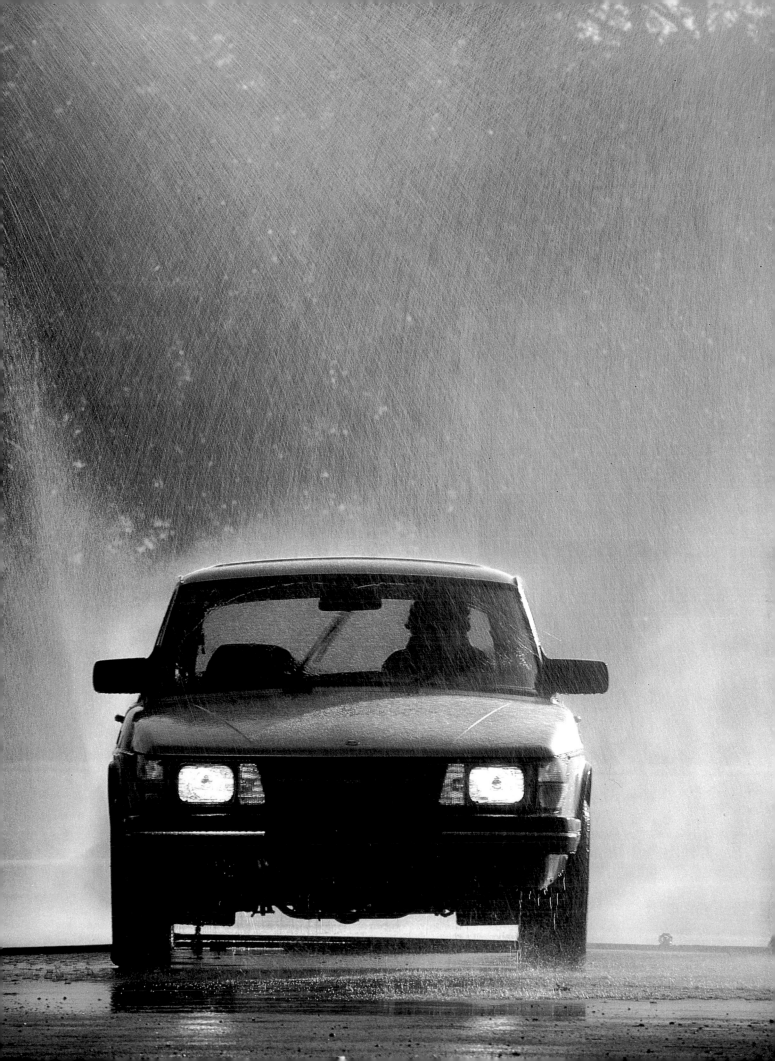

Creating a Sunny Place for Dole

We were very excited when we got the chance to bid on this campaign for Dole. It was obvious from the layouts that the art director had a good eye for design and we were anxious to get the job. Assignments like this are a pleasure to work on and we knew it had the makings of a great campaign. All we had to do was execute them properly and we couldn't lose. We competed against three other photographers and, even though ours wasn't the lowest bid, we got the job.

As soon as he had seen the boards, Al knew he wanted to shoot in the Bahamas. Since there were logistical problems involved in each shot, Al wanted to handle the actual scouting himself. He flew to the Bahamas to look for three distinct beaches. It rained the entire time he was there scouting, but Al was happy about that. He figured the weather could get it all out of its system.

While Al was away, I started production here in New York. The first item on my agenda was to call our talent agency in Miami and arrange for them to send us some Polaroids of bathing suit models for the client's approval. I requested some models that Al had worked with before and who he felt were right for these ads. We wanted girls who were "long and lanky" but still had some curves. Their faces weren't important because they would be obscured by hats or shadows.

I booked a stylist and sent her out to find various props and wardrobe. We also had a lot of things around the studio from previous shoots that would be considered. The stylist came back with some of the greatest swimwear and beach hats I've ever seen, but she had a few problems with some of the props. She managed to find an umbrella, but brought me a Polaroid of one of the most pathetic-looking lounge chairs I've ever seen. Luckily, a glance through my *New York Production Guide* (NYPG) located a great one. The only problem was that when boxed and ready to ship to the location, it was the size of a refrigerator. The stylist also couldn't find any hammocks, but fortunately we had

two great ones in the studio. We brought them with us and then painted them the appropriate color at the scene.

Since Dole is located in San Francisco, our client couldn't come to New York to give prop and wardrobe approval prior to our arriving on location. However, in advertising, it's always best to over-purchase. There usually isn't time to make changes, so the stylist should hedge all her bets. This is especially important if you are travelling to a remote location, where there will be no chance to buy replacements for anything that has been forgotten or wasn't right in the first place. A return day is usually built into the budget so that the stylist can return anything that was purchased but not used in the shoot.

Al gave preliminary approval on the models, props, and wardrobe, and the locations were all set. The plan was to shoot "Umbrella" the first day, "Chair" the second day, and "Hammock" on the third day. Even after choosing the locations, Al wasn't happy with the idea of shooting "Hammock" at the beach. He hoped that once we arrived, the art director would allow it to be shot at a pool location.

Dole Pineapple "Hammock" "Chair" "Umbrella" Production Schedule Bahamas

SUNDAY	MONDAY	TUESDAY	WEDNESDAY	THURSDAY	FRIDAY	SATURDAY
5 January	6 Bid Job	7	8	9 Approval of Estimate	10 PO Arrives by Fed Exp. Prep Casting for Miami Al Scout	11 Al Scout
12 Al Scout	13 Casting (2 sets of polaroids) Stylist - purchase wardrobe & props Al Scout	14 Casting Al Scout	15 Cast Polaroids sent to SF & Studio Al Scout	16 Telex Bahamas on sheet (incl. hedged corkets) overnight location polaroids Al - New York	17 Approval of locations from agency Approval of Cast	18
19	20 Al + crew leave for Bahamas finalize production & logistic problems	21 Agency, stylist & first model arrive Pre-pro meeting	22 Prep Beach Shoot Umbrella Prep Chair	23 Shoot Umbrella Shoot Chair Shoot Umbrella	24 2nd Model Arrives 1rst leaves Shoot Hammock	25 leave for New York
26	27 Film divided to be processed Production materials returned	28 Film sent to processing	29	30 Film Edited	31 Film Edited Film sent to agency	1 February
2	3	4 Agency Approval of take	5	6 Bill Agency	7	8

98

POOL/ Bahamas

Ekuthera

Rock Sound Club

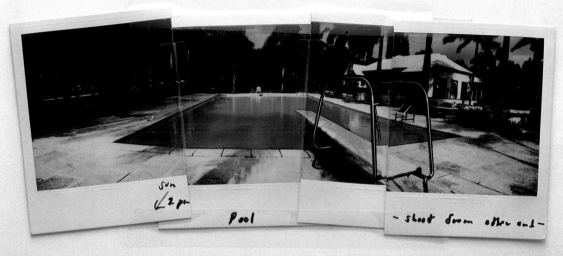

Sun
↙ 2 pm

Pool

- shoot from other end -

Pool good color
Rooms available
Airport - 5 min south
other beaches 45 min north

PM
2³⁰ SUN AM
 10⁰⁰

Rooms
$78 single

$102 double

The Rock Sound Club
Hotel and Restaurant
PHONE 334-2243 · BOX 97 · ROCK SOUND · ELEUTHERA

Creating a Sunny Place for Dole

I arrived at the island a day early with my assistants; the art director, account executive, and client representative flew in from San Francisco the following day; and Joy and the first model arrived from Miami that same evening. The accommodations on this particular island were not what you would call first class—in fact, it was stretching it to call them second class. But the locations were the best—and that's why we were here.

A quick meeting was called that evening so that the client could review all the props and wardrobe. He was pleased and we agreed to start shooting the next day.

The first shot was to be "Umbrella." We arrived at the beach I had chosen only to find it littered with debris. A storm was kicking it up on the sand and we were helpless in trying to get it clean. Every time we got one section cleared, the water would bring up more trash. Rather than kill the shoot, we moved to the opposite side of the island, hoping that we wouldn't have the same problem.

The new beach was clean, but the storm was definitely moving our way. The art director was worried about the clouds but we went ahead and set up the shot. The first shoot was taken in a hurry; the sun was sinking fast behind the ever-increasing clouds. We

didn't even have enough time to clear the footprints off the beach. I used a variety of lenses for all three shots. For "Umbrella" I worked with a Nikkor 16mm F2.8 semi-Fisheye, an 18mm F3.5, and a 20mm F2.8. It's always best to cover yourself in a situation like this. You try for a shot, unless it's impossible, because the client is paying a lot of money for you all to be on location.

We set up the "Umbrella" shot again at the end of the next two day's shoots to cover ourselves and the art director. Actually, all three days produced good photographs, but one from the second day's take proved to be the winner.

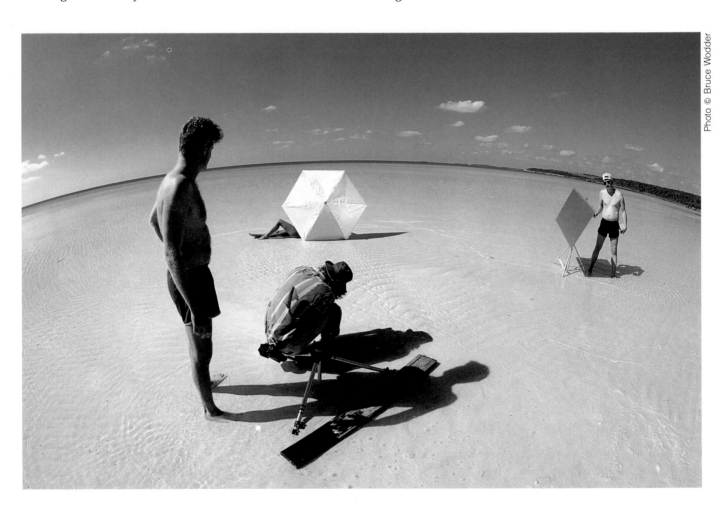

Photo © Bruce Wodder

Reprinted courtesy of Dole Pineapple

Rory Phoenix, art director; J. Walter Thompson (San Francisco), agency

Add a little Dole.
And taste where it takes you.

Taste a Sunny Place called Dole.

Even the everyday things you make can taste more lively and altogether new. For instance, a simple chicken salad. With the bright taste of Dole* Pineapple, new flavor bursts through.

Chicken Salad Riviera

1 can (20 oz.) Dole Pineapple Tidbits, drained	½ cup raisins
	½ cup toasted slivered almonds
1½ lbs. chicken, cooked, chunked	3 tablespoons sliced green onion
½ cup frozen peas, thawed	Sunny Dressing
½ cup sliced celery	Crisp salad greens

DIRECTIONS

Combine pineapple, chicken, peas, celery, raisins, almonds and onion in a bowl. Toss with Sunny Dressing. Serve on salad plates lined with crisp greens. Serves 4 to 6.

Sunny Dressing

Combine 1 clove pressed garlic, 1/3 cup mayonnaise, 1/3 cup dairy sour cream, 1 teaspoon ground coriander, 1/2 teaspoon ground cumin, 1/4 teaspoon dry mustard, 1/4 teaspoon ground cloves and 1/8 teaspoon cayenne pepper.

For more recipes, send a stamped self-addressed envelope to: DOLE'S QUICK 'N EASY RECIPES, Dept. M 86, P.O. Box 7758, San Francisco, CA 94120.

© 1986 Castle & Cooke

Dole Pineapple **Chunks** IN HEAVY SYRUP

Dole Pineapple **Tidbits** IN UNSWEETENED PINEAPPLE JUICE

I had found the perfect beach for the second shot, "Chair." The sand rippled out for what seemed like forever, covered with just 6-inches to 1-foot of water. It really was a beautiful spot.

We placed the lounge chair out in the middle of this expanse and I worked from above, standing on a 14-foot ladder. I used a Nikkor 28mm F3.5 PC lens, which allowed me to keep the lens pointed almost straight down and, by adjusting the lens, move the chair into the part of the frame that I wanted. The PC lens also allowed me to shoot without distortion and avoid getting the legs of the ladder into the shot. Reflectors were held off to the side of the ladder, just out of the frame, to bounce sunlight back onto the model. Joy secured the bathing suit in place with double-stick tape and we were ready to shoot. The model looked great, the weather couldn't have been more perfect, and I took every variation of the scene that I could think of.

We had so much time left over that I suggested we start checking out the locations for the "Hammock" shoot, which was scheduled for the next day.

I had found a deep-blue pool at one of the hotels, and really felt that it would provide a much better background than the green ocean water. It would have much more punch, making the scene look more graphic. After looking at the beach I had chosen, the art director agreed that it would be best to go with the pool and we made arrangements to shoot the next day. Unfortunately Dole moved to another agency before "Chair" was made into an ad, which is why I can't show you a tearsheet of the final ad.

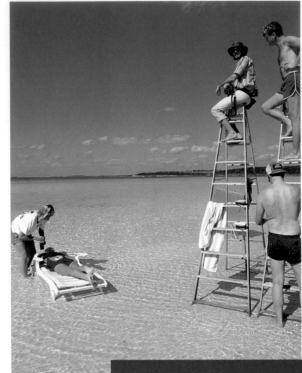

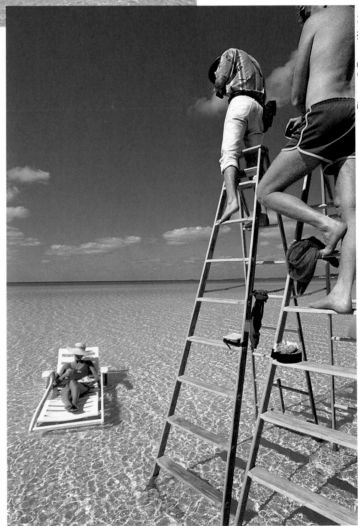

Photos © Bruce Wodder

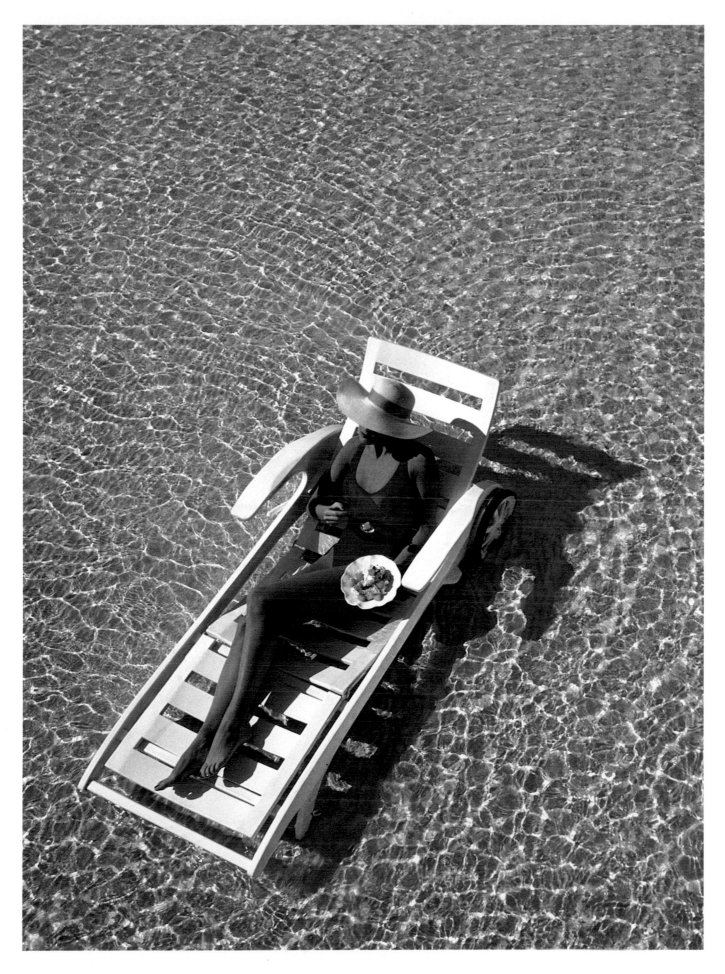

Creating a Sunny Place for Dole

The second model was late in arriving and we thought we might have to use the same model for all three shots. That wouldn't have been so bad, but we had chosen the second woman for her long legs. She would sink into the hammock once she was in position and her longer legs would compensate for the natural foreshortening of her body.

She arrived just in time and I had her try on all the bathing suits for the art director to make a final choice. We then handed her a bottle of nail polish to match the lipstick and sent her off to do her nails.

We had to get ready in a hurry; the sun was setting fast and it looked as if another storm was going to blow in. While the model was finishing her nails, the account executive was busy making the dessert that the model would hold. I had to hand it to the account executive—she made the most terrific looking dessert out of pineapple, Crisco, sugar, and food dye—I was impressed.

I was working on top of the 14-foot ladder again, still using the Nikkor 28mm F3.5 PC lens. I shot at f/11 with Kodachrome 25. Joy had applied body makeup to the model, which gave her an instant, flawless tan, and pinned her hat to her head so the increasing wind wouldn't take it off. The model climbed into the pool, up the ladder, and into the hammock. She was a great model and the shoot went fast. We were lucky and finished just in time—we had to break the set in the pouring rain.

We reviewed all the Polachrome later in the evening over drinks. There were smiles all around and I knew we had winners here—several of them, in fact. The art director called from San Francisco after reviewing the actual film and said they were the best shots ever taken for Dole.

Photo © Bruce Wodder

Reprinted courtesy of Dole Pineapple

Taste a Sunny Place called Dole.

With a little Dole® Pineapple, almost anything you make becomes more of a treat. And treats like dessert become a lot more refreshing. Dole Pineapple makes it easy— as easy as our cool-tasting pie.

Mellow Mai Tai Pie
(Non-Alcoholic)

1 pint pineapple or lemon sherbet, softened
1 pint vanilla ice cream, softened
¼ cup lime juice
2 tablespoons orange juice
1 tablespoon lemon juice
1 tablespoon grated lime peel
1 teaspoon grated orange peel
1 teaspoon grated lemon peel
1 can (20 oz.) Dole Crushed Pineapple, drained
Macaroon Crust

DIRECTIONS

Combine softened sherbet and ice cream with all juice and grated peel. Fold in pineapple. Pour into Macaroon Crust. Freeze until firm or overnight. Garnish with pineapple slices and lime if desired. Serves 8.

Macaroon Crust

Combine 2 cups macaroon cookie crumbs and ¼ cup melted butter. Press into 10-inch pie plate. Refrigerate until ready to use.

For more recipes, send a stamped self-addressed envelope to: Dole's PINEAPPLE DESSERT CLASSICS, Dept. J86, P.O. Box 7758, San Francisco, CA 94120.

© 1986 Castle & Cooke

Add a little Dole.
And taste where it takes you.

105

Going to Great Lengths for American Express

American Express wanted to display six billboards in Los Angeles during the 1984 Summer Olympics. The art director originally wanted the billboards to be shot in black & white; his theory was the black and white would stand out from the clutter of the other color billboards. Al disagreed and set out to convince the art director that color and design would make the elements so strong and graphic that the billboards would leap out at you. The art director initially made Al cover it both ways, but after the first shot he could see Al's point of view; the rest of the photographs were done only in color. All the ads were taken with a "Nikonwide," which shoots 35mm film that gives one exposure that is actually three frames long.

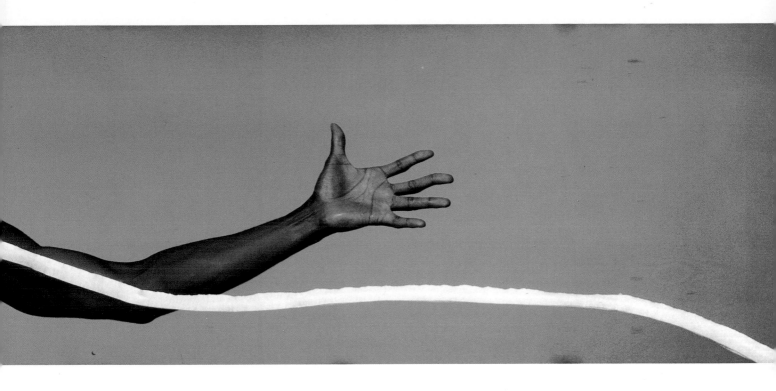

I like using 35mm equipment, so when it became necessary for me to work in 4 × 5 for a long-format shot, I would cringe. The 4 × 5 and even 8 × 10 cameras are too cumbersome for my style of working. I checked out some "wide-angle" cameras, but they distorted the image too much. The only solution was to have a camera built to meet my needs—hence the "Nikonwide" (at least, that's my name for it). It's a 35mm Nikon adapted to shoot a format three times as wide as a regular 35mm camera (24 × 108mm compared to 24 × 36mm).

A Nikon body was cut in half and stretched; the shutter, mirror box, and prism viewer were all removed. The camera was adapted to use an optical viewfinder or ground-glass back for very accurate alignment. It has two interchangeable lenses: a Schneider 65mm F5.6 and a Nikkor 135mm F5.6. The Compur shutter in the lenses replaces the focal plane shutter that was removed from the original body. A Compur shutter is used in Hasselblad lenses and most view camera lenses. It consists of a number of small, overlapping metal blades. When fired, they open up and close again, unlike a focal-plane shutter's slit that travels across the film plane. It has a complete range of speeds from Bulb through $\frac{1}{500}$th sec., and it syncs with strobe at all speeds (whereas a normal focal plane shutter will only sync at $\frac{1}{60}$th sec., $\frac{1}{90}$th sec., $\frac{1}{125}$th sec., or $\frac{1}{250}$th sec., depending on the model). It is built into each lens instead of the camera body, which makes the lenses very expensive pieces of equipment.

There's almost no distortion on the extreme edges because the super-wide-angle, 65mm view-camera lens becomes normal on the 35mm camera. Thus the Nikonwide is a wide-field camera instead of a wide-angle camera. It's the 35mm equivalent of the 2¼ Linhof Technorama, but it is much smaller and handles like my other Nikons.

All sketches courtesy of Ogilvy & Mather

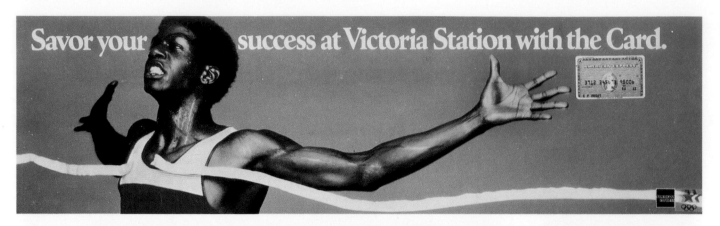

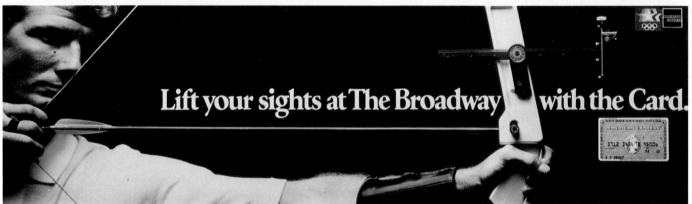

Peter Weir, art director; Ogilvy & Mather, agency

The first five billboards were shot in the studio. The sixth, the swimmer, was shot on location in a health club in New York. The backgrounds were to be kept as simple as possible to increase the impact of the shots. I chose seamless in colors that contrasted with the wardrobe or props for the studio shots and then lit them with gelled strobes to intensify the colors—I wanted them to be as bold as possible. The background for the swimmer shot was the bright blue water of the pool. I left the red racing ropes up to add another design element to the shot. The lighting was kept simple, just one bank light or soft box for each model.

We decided to cast real athletes, since they all had to utilize some sort of skill. Even though we used an actual weight lifter, the bar was mounted on stands at the proper height so that he only had to look as if he was straining and not actually

hold the bar bells. We didn't want to have an injury or tire him out in case it was a long shoot. The gymnast was the most difficult model to cast; she is doing a real split on the balance beam and only her feet were touching the beam. The soccer player is a gym instructor that someone recommended to us. The ball was thrown into the scene by an assistant off camera. The archer held an untensioned bow string; again, we wanted to avoid the possibility of an accident.

The shot of the runner involved a little "business." The finish line tape was pre-broken and glued onto armature wire, which held it in position. We sprayed a fine mist of water onto his face periodically for realism.

Everything was designed to be clean, simple, and graphic. When the art director received the final film, all he had to do was select the right shot for each take and trim a little excess off each end.

All photos courtesy of American Express Company, Travel Related Services

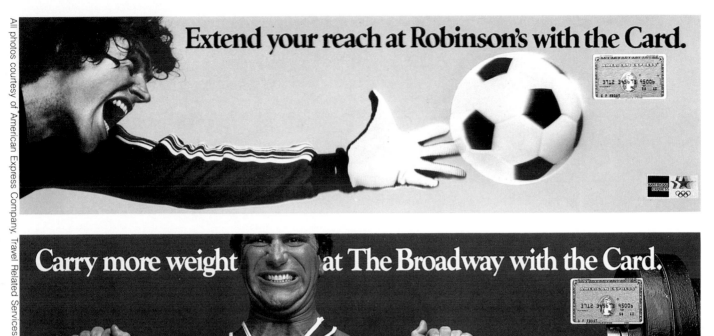

Extend your reach at Robinson's with the Card.

Carry more weight at The Broadway with the Card.

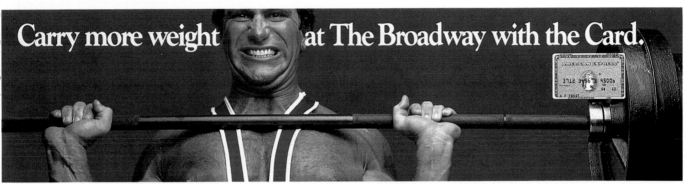

Taste victory at Parker's Lighthouse with the Card.

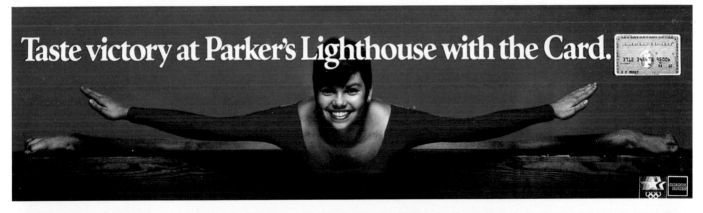

Taste victory at The Chart House with the Card.

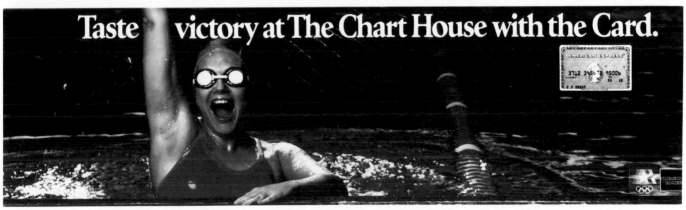

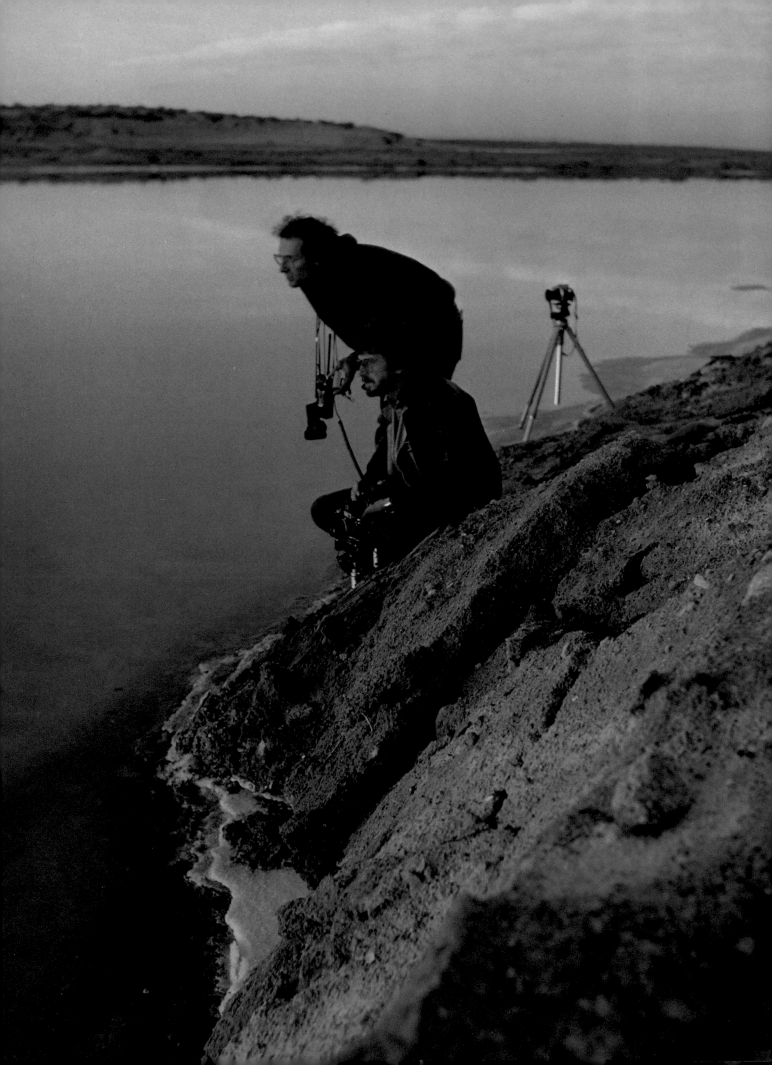

BEHIND THE SCENES

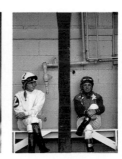
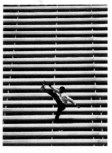

Equipment and Packing

Packing equipment is an art. Photographers can spend many hours custom planning the system that works best for them. Their first concern isn't simply that the equipment arrives on location undamaged; they also need to determine how much equipment to bring in order to cover the parameters of the job. Many shooting locations are isolated, so it's a mistake to count on ducking into a convenient camera store to pick up a forgotten piece of equipment. That's why planning the kinds of carrying cases you are going to pack, and organizing what goes into them and how they are padded is essential.

In addition, it's smart to have a contingency plan in case something goes wrong and one of your cases doesn't arrive. Pack your strobes, for example, as complete units, with each case containing a power pack, two strobe heads and the necessary cords and accessories. Imagine putting all the heads in one case and all the power units in another—what would happen if the case of heads didn't arrive?

Keep in mind that buying the heaviest carrying case won't solve the problem of luggage being roughly handled; instead, protecting your equipment with padding is the answer. Never stack equipment directly on top of other equipment—always pad generously in-between. A well-padded tripod case, for example, can hold three-to-four tripods of various sizes.

You'll also want to pack small things like spare model lights and flashtubes, tools for making minor repairs, and other odds and ends. Bringing a grip case filled with clamps, attachments, rope, glue, hammers, nails, staple guns, and an assortment of tools and other handy paraphernalia along with you on location can be a real lifesaver. It can help you accomplish just about anything short of a miracle. (Of course, you need to have some talented assistants who know how to use the stuff.)

If you are traveling by air, all of these cases can be shipped inside the airplane hold. Your cameras and lenses, however, are only truly safe when you carry them on-board the plane with you. Whatever your means of transportation to a location, don't let cameras and lenses stray too far from your side. As long as you have access to them, you can still take pictures, no matter what happens to the rest of your equipment.

Over the last twenty years, Al has been testing equipment and updating his preferences as photographic technology has evolved. What follows is a list of the equipment that he owns, uses, and knows that he can recommend and stand behind, as well as his methods of adapting this equipment for special purposes.

Strobes

Al only owns two large strobes—an 800-watt-second Luz and a 1600-watt-second Luz—because he finds that keeping two strobe units is adequate for doing simple jobs and experiments. Most of his jobs require that he rent between four and twenty additional strobes, but he doesn't want to own that much equipment, because strobe technology is constantly changing; in order to own state-of-the-art strobes, you would need to update your equipment every five or six years. Al also owns four Balcar light heads that have been extensively modified so that they work perfectly with his Luz strobe units. Since the Luz units were designed and built by a strobe repairman at Electro-Foto in New York City, these strobes are very versatile and rugged, and will withstand use at 100°F as well as at −5°F. Moreover, they are compact and travel well. Al packs each Luz unit with two heads plus all of the unit's accessories in a well-padded A&S aluminum case. Then he packs a third case with a Norman 200B battery-powered strobe (modified to 400-watt-seconds) with two Protech gel-cell batteries that recharge in 30 minutes. This case also carries two Lowel Tota-Lights, cords, and accessories.

A&S aluminum cases

Luz 164XL (1600-watt-seconds) flash generator

Balcar light-head extension cable

Luz 83XR (800-watt-seconds) flash generator

Dyna-Lite receiver

Balcar Pencil Lite

Dyna-Lite transmitter

Spare sync cord

Super Slaves

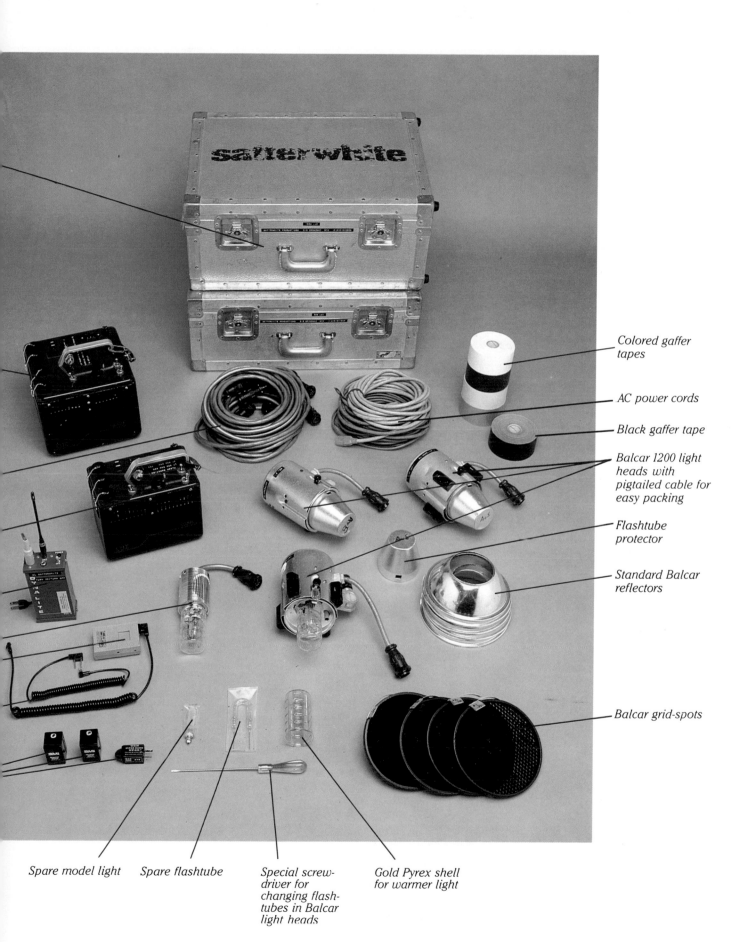

satterwhite

Colored gaffer tapes

AC power cords

Black gaffer tape

Balcar 1200 light heads with pigtailed cable for easy packing

Flashtube protector

Standard Balcar reflectors

Balcar grid-spots

Spare model light Spare flashtube Special screwdriver for changing flashtubes in Balcar light heads Gold Pyrex shell for warmer light

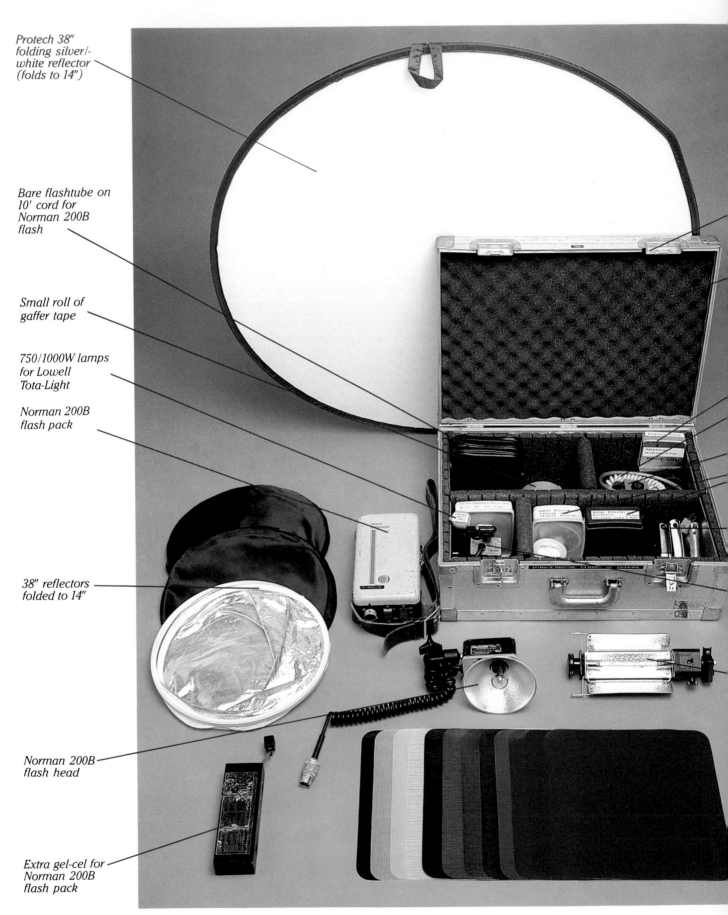

Protech 38"
folding silver/-
white reflector
(folds to 14")

Bare flashtube on
10' cord for
Norman 200B
flash

Small roll of
gaffer tape

750/1000W lamps
for Lowell
Tota-Light

Norman 200B
flash pack

38" reflectors
folded to 14"

Norman 200B
flash head

Extra gel-cel for
Norman 200B
flash pack

Cameras and Lenses

Al uses Nikon cameras because they are lightweight and make changing lenses very fast and easy. Nikon cameras come with many different options, such as motor drives, high-speed motor drives, action finders, waistlevel finders, extremely wide lenses, close-focusing lenses, very fast lenses, and very long lenses. Also, Nikon equipment can be customized to fit your needs.

Al owns and uses more than 20 Nikkor lenses. He tests all of his lenses to discover where their strong and weak points are. Some Nikkor lenses can be used wide open and stay very sharp, while others must be stopped down for maximum per-

formance. After Al determines their limitations, he marks the lenses accordingly. He carries a lot of lenses with him on assignments because he never knows what problems he will find. Frequently, a photographer cannot move forward or backward to correct his perspective; instead, the only option is changing focal lengths, or changing lenses. If you want, you can throw the background out of focus by going to a longer and faster lens. Al often shoots a situation by using several camera bodies at the same time. What is most important is always having a variety of cameras and lenses with you, so that you can choose the right one to solve the problem.

A&S aluminum case

Silver, white, and black boards behind foam padding

Cords for wiring Nikon motors together

Extension cord

Adaptor for using Norman 200B flash pack with Balcar light heads

Remote cords for Nikon motor drives

Three C-clamps

Small light that works off AC or auto battery

Lowel Tota-Light (750/1000-watt)

Plume "Fire Ice" colored gels for use with strobes

I needed a camera for shooting really wide formats because some of the advertising work that I do is displayed on billboards. I had tried using 4 × 5 and 8 × 10 formats, but found the cameras too cumbersome. I really wanted a stretched-out version of my 35mm Nikon—so I had one built. It

has a very wide frame (24 × 108mm) without a wide angle, and it records an area three-frames-wide. It has two interchangeable lenses, a 65mm and a 135mm, as well as an accurate optical viewfinder for action shooting and a ground-glass back for even more accuracy. It gets twelve frames to a role of 35mm film.

I never ship cameras—they fly with me. This way, I know I can always take pictures even if none of my equipment cases ever arrive. I carry four camera cases onto the airplane with me: two Rox aluminum cases for carrying my lenses, and two Lowe shoulder bags. I've found this to be the most flexible combination, because once I'm on location I can take all the equipment I need and put it into the two shoulder bags, leaving the aluminum cases in a car trunk or somewhere safe. This strategy has come in handy many times, especially when working under adverse conditions, such as out of a helicopter, at the beach, or in the desert.

The two medium-size Lowe shoulder bags fit beneath airplane seats. One bag contains two Nikon bodies with motor-drives; a strobe meter; a spot exposure meter; a color-temperature meter; two walkie-talkies; a Nikon body with a Forscher Pro-Back for Polaroids; a plastic, waterproof container holding Kodak color-correction gels and adapters; and two plastic, waterproof containers, each holding 16 rolls of Kodachrome 25. These film containers are wonderful—I take the film out of the boxes and plastic cans (which cuts down on bulk) so the airport security can easily see what I am carrying aboard when I request a hand-check at their x-ray portals. When I'm working, I put the exposed film back into these con-

FM transceivers

52/72mm gelatin-filter holder

Lowe-Pro Compact 35 shoulder bag

Plastic containers for 16 rolls of Kodachrome 25

Two Nikon F2 cameras with MD-2 Motor Drives

Hasselblad Tripod Quick Coupling

Swiss-army knife

Minolta Spotmeter M

Minolta Flash-meter III

Minolta Color-meter II

Nikon F2 camera with Forscher Pro-Back

tainers upside down—that way, I can tell at a glance how much film I have left to expose. Getting rid of the film boxes and cans beforehand means that I don't have to deal with extra trash on location. The second shoulder bag holds another Nikon body with motor-drive; a Nikkor 200mm F2; a small tool kit; a flashlight; spare batteries; a small Leitz table tripod; a spare Nikon body; and two more plastic containers of Kodachrome.

Polaroid 669 Twinpack film (for Pro-back)

Polachrome film

Nikkor 200mm F2 lens

cable release in lid

Nikon F2 camera with MD-2 Motor Drive

Spare batteries

Compass

Tool kit

flashlight

Leitz tabletop tripod with ball-and-socket head

Nikon F2 camera body

Equipment and Packing

The two Rox aluminum cases are well lined and padded. Each lens has its own place in one of the cases, and I insist that it be returned there when I am through working with it. All the lenses and rear caps are labeled so that my assistants can easily tell them apart. I pack all my short lenses (16mm to 135mm) in one case; the other contains the long lenses (180mm, 300mm, and 400mm), as well as the huge 15mm lens, action finders, waistlevel finders, 72mm glass filters, and an adjustable bellows lens hood. All my lenses are adapted to take 72mm filters so that I won't have to carry different-size filters for every lens. (Filters range in size from 52mm to 72mm.)

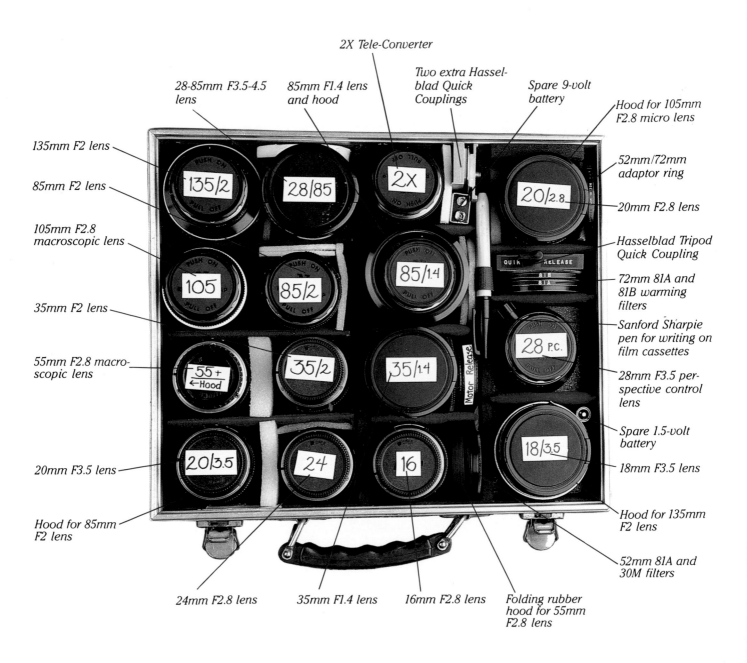

2X Tele-Converter

Two extra Hasselblad Quick Couplings

Spare 9-volt battery

28-85mm F3.5-4.5 lens

85mm F1.4 lens and hood

Hood for 105mm F2.8 micro lens

135mm F2 lens

52mm/72mm adaptor ring

85mm F2 lens

20mm F2.8 lens

105mm F2.8 macroscopic lens

Hasselblad Tripod Quick Coupling

72mm 81A and 81B warming filters

35mm F2 lens

Sanford Sharpie pen for writing on film cassettes

55mm F2.8 macroscopic lens

28mm F3.5 perspective control lens

Spare 1.5-volt battery

20mm F3.5 lens

18mm F3.5 lens

Hood for 85mm F2 lens

Hood for 135mm F2 lens

52mm 81A and 30M filters

24mm F2.8 lens

35mm F1.4 lens

16mm F2.8 lens

Folding rubber hood for 55mm F2.8 lens

72mm polarizing filter

15mm F3.5 lens

Action finder

72mm filters (81A, 81B, 81C, 85B, 4X ND)

300mm F4.5 lens

Pen

180mm F2.8 lens with 1.4X Tele-Converter (250mm F4)

Adjustable-bellows lens hood

400mm F5.6 lens

52/72mm adaptor for bellows hood

Two sets of Nicad batteries for motor drives

72mm gelatin-filter holder

72mm filters: low contrast 1 and 2, fog 2, 30M

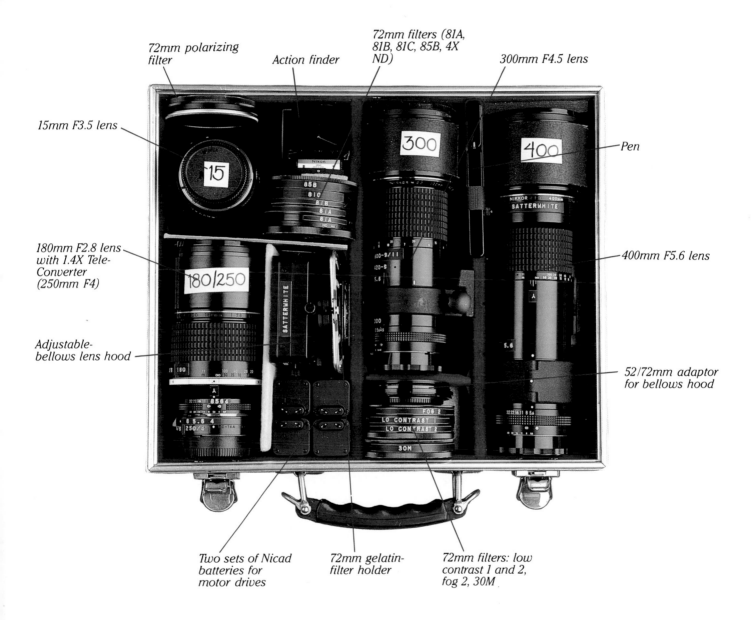

Equipment and Packing

Motor Drives

Al uses motor drives for shooting everything, mainly because they minimize camera movement when winding or rewinding film. Motor drives allow you to control the shutter release electrically, and to wind and rewind film without actually having to touch the camera. Al sometimes wires as many as ten camera bodies together, and then fires them all at once using one control. Motor drives make it possible to put cameras in places that are hard to shoot from so that the photographer can fire the cameras electrically from a distance. All of Al's motor drives are modified with a permanently attached Hasselblad quick-coupling release, which allows the camera to be quickly removed from the tripod and replaced by a freshly loaded body. When shooting, Al always uses at least two cameras interchangeably to cover himself; that way, if one camera body should malfunction, he still has the rest of the take in the other camera. The quick-coupling release makes it easy to change camera bodies back and forth.

Tripods

Tripods establish a solid shooting position for camera work, so Al uses them whenever possible, because they allow him to frame an image exactly the way he wants it and to "lock off" his camera position. Although he seldom used tripods during the first ten years of his career (he felt that they were too cumbersome and slowed him down), now he never travels with fewer than three. Tripods add to your shooting options—for instance, being able to expose an image for more than a second using a camera on a tripod can mean the difference between success or failure in getting a picture. Tripods are also critical when positioning several cameras to be fired simultaneously. Al likes the Gitzo tripod best, because Gitzos are rugged, dependable, and they last forever. Al's tripods all have heavy-duty 8 × 10 heads on them, are fully adjustable in two directions, and rotate 360 degrees. A tripod is the most solid support for a light-weight 35mm camera. When select-

ing a tripod, you can test it by mounting a camera with a 400mm lens on the tripod and shooting at 1/4 sec. If every frame is sharp, then you have a solid tripod. Keep in mind that a shaky tripod is worse than no tripod at all.

Radio Controls

Al considers using radio controls to fire his strobes a necessity. Radio controls free a photographer from worrying about tripping over his sync cord or about the constant surge of power that the sync cord carries into his camera. Radio controls make triggering strobes for exposure-meter readings much easier, too. To maintain your radio controls, change their batteries twice a year, and have each unit checked once a year.

Miscellaneous

Al uses several kinds of folding reflectors, including a large, folding Lowel reflector, which comes in handy for filling in shadow areas. Compared to strobes, reflectors are hotter and faster to use, because their silver mylar coating reflects nearly 100 percent of the light thrown onto it. He also carries a large 30 × 40-inch case containing three 4 × 8-foot white foamcore boards that have been cut and taped to fold for easy transport. Al uses these boards for fill when a softer look is desired. This case also holds several large, stiff cards in white, silver, gold and black. Al uses them as fill reflectors or to deflect light from the camera lens or the subject area. He carries the stands for these cards in a separate case.

Al also brings six empty, refillable sandbags with him on location. His sandbags are made by Maverick of Venice, California, and look like small saddlebags with zippers. There are two pockets per bag, and each pocket has a double set of zippers to keep the sand from sifting out. They are very lightweight to carry, and once on location, are filled with sand, gravel or small rocks. They are then hung from light stands, tripods, or anything that needs to be weighted for stability. When the shoot is over, they are easy to dump and repack.

Film and Processing

A photographer's reputation is based on his or her creativity and skill, and these depend greatly on choosing the right tools to execute various assignments. No choice will have a greater impact on a job's outcome than the film you decide to use. Film stock affects photographic style as well as quality. For instance, if a job is shot on film that hasn't been aged properly and the chromes are too green, the art director will try to save the shoot by giving the film to a retoucher to be color balanced. Once the retoucher starts working

with the film to compensate for the color imbalance, the results of using non-aged film won't please you or the art director. The lesson here is to never buy film without testing it first.

Try to buy new stock at least twice a year. Since new film is literally green, store it for four-to-six months before using it. This allows the film to age properly. As film ages, it turns warmer in color. To test emulsions, shoot a roll from each batch of film being considered, and use a subject who is standing in two different kinds of light (such as strobe light

and open shade outdoors) and is holding a color-control patch and a gray scale (the *Kodak Color Dataguide* contains a good one). Then check the results. If there is too much green or a magenta bias, the film will not age properly. Look at the skin tones, the white areas, and the gray areas. If the film tends to be green, it will really show up in the shadows. Once you settle on an emulsion, buy a case (three hundred rolls) of that batch number, and store this film in a cool, dry place so that it will age properly. *Never refrig-*

A

B

C

Chrome A was the winner in this test group. A has a warmer quality to it, which is what I like. B is okay too, but I felt that A would give me superior color saturation, and that my reds would be more vibrant. (Look at the picture of the red umbrella on page 51. That is the way I like my reds—I like them to leap off the page.) C is a definite loser—it's far too green. It would never turn warm enough to suit my taste.

erate new film—refrigeration retards the aging process. After the film has reached full maturity, then you can refrigerate it.

Color bias is really a matter of personal taste. It is a good idea to test several types of film and become familiar with them. Then you can make an intelligent choice and buy film stock that you prefer based on an understanding of its limitations. While you are at it, test different labs, too. Although labs send Kodachrome to Kodak for processing, how E-6 based film is processed can vary from lab to lab, and from day to day. You can learn to accurately predict how a shoot's results will look if sent to one lab or to another.

Labs also differ in the kinds of quality control they exercise, and in how they service their clients, for example: whether or not they deliver film on time; the accuracy of their accounting when they bill customers; the consistency of their E-6 processing from run to run; and whether chromes are mounted correctly. If a lab can't produce consistent results on a daily basis, then it's time to find a new lab. Happily, there are some very competent labs out there, and they want your business.

We look for a lab that will service us the way we service our clients. Al likes to have a good rapport with a lab, and he expects the lab to answer his technical questions about processing, if he has any. Since he doesn't have time to do his own lab work anymore, he finds it very important to trust a lab's ability to produce the kind of results he needs.

A warning for people who travel with their film—don't expose your film to x-rays because they are cumulative. Everytime you send your film through the x-ray machine, x-rays collect on the film and destroy its D-max (a chemical breakdown that makes blacks look brown and muddy, and makes the film lose its contrast). A large dose of x-rays can cause the film's sprocket holes to imprint themselves on the film. Polaroid and high-speed films are very sensitive; films with slower speeds are less susceptible. X-ray damage can remain undetected until the film is processed and it's too late to reshoot, so avoid x-rays at all cost. Remove your film from its containers and place the rolls in Tupperware plastic tubs that each hold sixteen rolls and can easily be hand-checked by airport security.

Duping

If you really like an image, it is difficult to allow the original to leave the studio. There is too much risk of its getting lost or damaged. Hence many photographers are also proficient "dupers" who know how to make professional duplicates of "reproduction quality" of their work. Sometimes the dupes turn out to be better than the originals. But protecting originals is not the only reason for duping chromes—you can make new images by combining two or more originals, or you can enhance a chrome's color or boost its color contrast. Once the dupes are made, "masters" can be stored in a file where they are safe until the next time you need them to make dupes.

Most of our duping is done on Kodachrome 25 that we process normally, although special duping film is available, too. It's an E-6 base film with a very slow speed and fine grain, and it has a built-in, lowered contrast. Al feels that dupes made with this film look like "dupes." Also, duping film has to be filtered differently from batch to batch. You should test your duping film the same way you would test any other film and mark the results down for later reference. Buy duping film in a large quantity; otherwise, you will have to retest your film if it doesn't have the same batch number. You can store duping film in the freezer.

Al does all his duping on an Ilumitron, a sophisticated machine designed exclusively for copying chromes at 1:1 magnification ratio (or higher), yet it is very simple to operate. Like most duping machines, the Ilumitron consists of a body that houses a small strobe tube and modeling light on an adjustable stage. It has a front panel with a very accurate built-in metering system for determining correct exposure, high/low switches, on/off switches, and a light that tells when the unit has recycled. On top of this housing is a transparency stage that holds the chrome to be duped. Under the stage is a filter drawer for correction filters (gels). Above this is the flashing or fogging unit with a piece of optical glass (set at 45 degrees between the camera lens and the chrome being duped) that pre-

vents distortion. Also mounted to the housing is a column that holds a bellows unit that is fully adjustable. You mount your own lens and camera body onto the bellows, add a magnifier and a cable release, plug the unit's strobe sync into the camera and you are in business. Your lens should be very sharp and render an image ratio of 1:1. Macro lenses and high-quality enlarging lenses are excellent choices.

The Illumitron pictured above is the machine I use to duplicate original 35mm chromes.

Duping

Because Kodachrome 25 doesn't have a lowered contrast built-in, to use it for duping you'll need to "fog" your film at the time of exposure. Fogging or flashing film can be accomplished in several ways. If your duping machine doesn't have a built-in fogger, you can flash your film by first exposing the chrome you are copying, removing the chrome and reexposing the film with a ND2 (neutral density of 6⅔ stops). This will take a little experimentation to do well. Other methods include duping through a piece of optical glass set at a 45-degree angle with another light source aimed at it, or you can insert a fiber optic into the bellows between the lens and the film. Both methods will effect a lowered contrast. Another method, which requires a lab or darkroom, is called masking. To mask your film, you will need a pin-registration system. Masking allows you to control the film's highlight and shadow areas individually, whereas with the flashing techniques you cannot.

Before you begin duping, clean each chrome thoroughly. Dust can be a big problem. Every time you change a chrome to be duped check your focus, because every chrome has a different focal plane. The focal point may vary as little as a millimeter, but these tiny errors will add up. Al added a magnifier to his camera body and that helps immensely. Be very methodical and neat when you dupe—duping is extremely time consuming and it's a shame to have to dupe the same image again.

I named this image "Lonely Road." It is a combination of two shots: New York and the Arizona Badlands. I photographed the New York portion many years before I took the Arizona chrome. I was sitting around in the studio one day with a lot of time on my hands and decided to get out a bunch of chromes and play around. This double-exposed dupe was one of the results. This shot has been sold over and over again through The Image Bank, and it has been selected repeatedly to run in photo magazines. Many people have asked me when I'm going to make a poster of it.

Duping

The bottom half of this shot was done for Puch bicycles. It was a rather ordinary shot of men bicycling by a lake. I got the idea to sandwich it along with an image of a building photographed from below and with my stock moon shot. It gave the final picture a futuristic look. This shot is also a big seller with my stock agency, The Image Bank.

Recognize my stock moon? I have tons of chromes on file of moons, suns, clouds, buildings, silhouettes— all perfect elements just waiting to be combined.

This shot of a Parisian was okay alone—but when I sandwiched it with a shot of the side of a wooden house it took on a surreal quality that makes it twice as exciting.

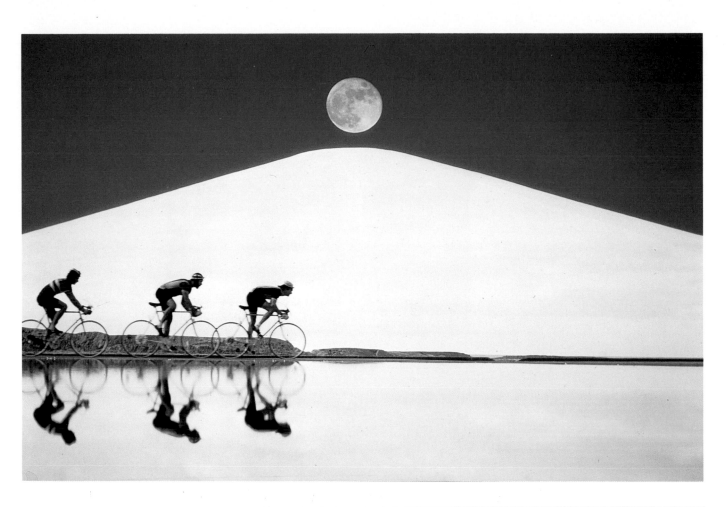

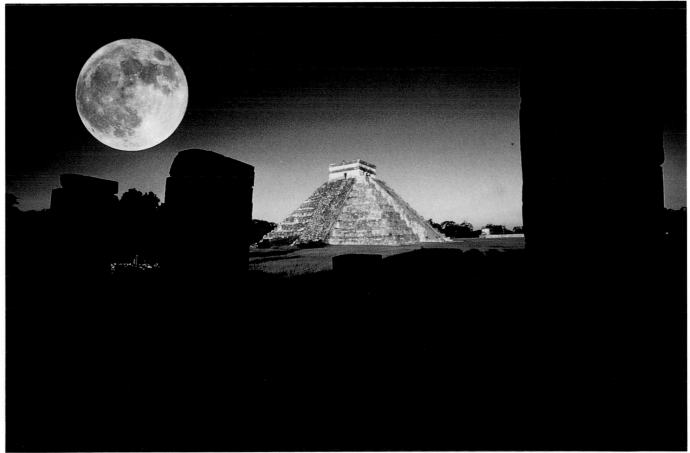

Duping

I did this first shot for the Hyatt Hotels Co. I liked the corner room and the see-through walls. Nature wasn't co-operating that day though, so I gave it a little help with the second shot: my stock sunset chrome. What a difference!

128

Hiring a Staff

Next to you, the photographer, the most important person in your business will be your representative or agent. What your representative does or doesn't do will make an enormous difference to your success and growth. A "rep" is responsible for generating new work and maintaining your house clients. A good representative should intimately understand your business and how to market your work, because he or she will be following up on promising job leads with promotion pieces and phone calls. Your rep should be able to plan your business strategy with you. A photographer is, if you will, a kind of product. The agent's job is to advertise and let art directors know about the availability and benefits of the agent's "product," the photographer, which requires more than the agent's going door-to-door with your portfolio.

Finding the right rep can be difficult, so do your homework first. Check the photographic source books for the names of representatives and then ask art directors and art buyers for their opinion of these people. Remember that the representative is usually the first person from your business whom your potential clients will meet. It is important that you feel that your agent represents you the way you want to be represented. He or she should reflect your ethics, taste, and judgment. Hiring a representative is like taking on a partner, so choose wisely. You need someone who is hard-working and trustworthy. Anyone can carry a book around—you need someone with resources, someone with ideas. One word of caution: since this person is in effect your partner, do put in writing any agreements made between you. Verbal agreements may hold up in court, but over time, who agreed to what can become elusive. If it's written on paper and signed by both parties, that puts an end to any argument. It isn't necessary for a lawyer or notary public to witness the agreement in order for the document to be legal, so for everyone's benefit, put your business arrangement with your agent on paper.

There will probably come a time when you decide that you need to hire a support team of workers. To keep your overhead at a minimum, most of your personnel should be freelance. Don't wait until the last minute to start interviewing—do it now while you have the time. Begin by logging all your interviews with prospective staff, so that when a job requiring help comes up, you'll have a system for recalling candidates who interest you. Take Polaroids of the applicants and staple the pictures to their resumes—it's a great method for jogging your memory of the interviews. Make notes on what was said during each interview, and once you have worked with someone, keep notes on file of how well he or she works. Your freelance staff is a valuable resource that can really make or break you, so choose it carefully. What follows is a description of the different professionals whom you are likely to need and hire.

Assistants

There is no point to hiring assistants who contribute nothing to your shoot. Unfortunately, there are very few good and experienced assistants, but there are millions of beginners. The reason for this is that the experienced assistants are pushing to get their own photography business started. During your interview, ask assistants when they see themselves going out on their own assignments, and don't be afraid to use the most experienced people. If you need a large crew, then hire the third and fourth stringers as extras. Remember that the experienced assistants have been working with and learning from your competition, who may know something that you don't. A good assistant can be invaluable to you. Because they are working at different studios, they get a good cross section of information that they hope will one day help them to become photographers. Right now that information could be very beneficial to you, so pay attention. Just because you are "the photographer" doesn't mean you know everything.

Office Help

Nothing is more unprofessional than a bill that is poorly put together and presented. Find someone who can handle your bookkeeping, phones and paperwork. You will make a better impression on your clients if your phones are answered courteously and professionally by a staff member. People still don't like to call a business and talk to a service or a machine. Remember that the experience of working with you and your company is just as important to your clients as the final outcome of the job you shoot. So make that experience a pleasant, professional one.

Special Effects People

Start building a file on model-makers and set builders or "scenics" for the jobs that will need special props or miniature sets. These artists can be found in the *Creative Black Book* or the *NYPG*. Interview them at their studios, look at their books and *ask questions*—their knowledge is immense, and they are full of "tricks." Scenics do anything that directly relates to creating a scene. You can even rent from them such unusual sets as airplane interiors, exteriors, and whole body sections. Art directors are very impressed if you think their "impossible production problems" are a breeze, because you know where to find the solutions. You will also want to become familiar with backdrop painters, who carry backdrops already in stock and will also paint them "made to order."

Knowing where to go to get what you need is half the production battle. It is a good idea to be familiar with a variety of scenic shops because their services do vary. Ask to see their catalogs, and learn what they actually keep in stock. Doing this kind of research beforehand will enable you to give your clients a much more accurate estimate.

Stylist

Stylists are best found by word-of-mouth. Your assistants will know who's working where, and based on that assistants can make recommendations to you. Good stylists are always in demand. Since your jobs are usually awarded at the last minute, it's a good idea to be prepared and have the names of three or four on file.

Different stylists have different strengths. Some will be good at fashion, but "slice of life" realism is really beyond their comprehension. Some may be great with props and sets, and some may not. When you are interviewing them and looking at their books, ask questions about what they contributed to the shots. Keep notes on their relative strengths and weaknesses.

Stylists work on day rates, so you should agree up front what that rate is and how many days you are willing to pay it. Most stylists will want cash advances for the props and wardrobe that they will have to buy. Avoid misunderstandings by making sure they understand what your budget is. Always get an itemization and receipts of all money spent on your job before you pay the stylist. Stick hard and fast to this rule. You won't be reimbursed by your client until you hand over the receipts, so why should your stylist expect preferential treatment?

Hair-and-Makeup Artists

There are source books that explain where to find hair-and/or-makeup talent, but once again, using word-of-mouth is best. Stylists and assistants will also have recommendations. The price range for these professionals is between four hundred and five thousand dollars a day. Make an accurate judgment of how "heavyweight" a talent you need, remembering that just because someone's rate is five thousand dollars a day doesn't mean that person is the best for your job. Usually the "high-fashion" hair-and-makeup people command the higher rates, but you can find very good talent in the four hundred to eight hundred dollar range. Many of these people do work in television production.

Home Economist

Ask your art director's advice on finding a home economist to prepare or style any food product. If the art director consistently works on food accounts, then it makes sense that he or she has worked with many home economists and has some definite ideas on who's good and who's not. The *New York Production Guide* (or *NYPG*) is another good source. Los Angeles' best source book is *L.A. 411*. Usually you only need a home economist when you are shooting food that is a prominent part of the ad. Otherwise, talented stylists and assistants can style food. There are many multi-talented people out there. Be curious about the people you work with; ask questions.

Producers

On a big shoot, the producer is responsible for bringing the whole shoot together. Producers are the very necessary instigators and organizers of large or complicated shoots. Without them, production details tend to fall through the cracks. Producers can be hired freelance, but having a full-time producer is recommended if you work on a lot of heavy-production shots. It is hard for the producer to control a job when he or she isn't really a part of the everyday working process. A freelance producer could miss information that would be important to know in order to make decisions on your behalf. A lot of photographers are hiring people who double up on two functions, such as "producer-reps" or "studio manager-producer" or "first assistant-producer" or even "stylist-producer." These roles function well together and save you money on overhead.

Stock Photography

If you have been shooting for a while you probably have quite a pile of chromes sitting around somewhere gathering dust. Maybe once in a while someone calls you and asks if you have any existing shots that you would consider selling for stock. So do your chromes get a fair chance in the stock market?—not if you don't advertise, and not unless you're out there pursuing sales. But who has the time, right? Stock agencies do, and in addition to representing you, they throw in a bonus—pushing your name along with theirs often results in new, unsolicited shooting assignments for you.

Many photographers feel they should hang onto their chromes to make sure they are kept safely; yet most hate dealing with people who are looking for stock photography. Endless requests for all sorts of images means spending hours looking through files rather than making photographs. Keeping track of what shots are circulating and what has been returned is tedious, too, and there is always the danger of losing track of chromes. Often potential clients hang onto work for months at a time and then send it back without buying anything, which is a real waste of time and energy. Stock agencies take care of all these problems for photographers, who simply refer inquiries for stock pictures to the agencies representing them. Photographers enjoy shooting pictures, not selling them (which agencies generally do better, anyway).

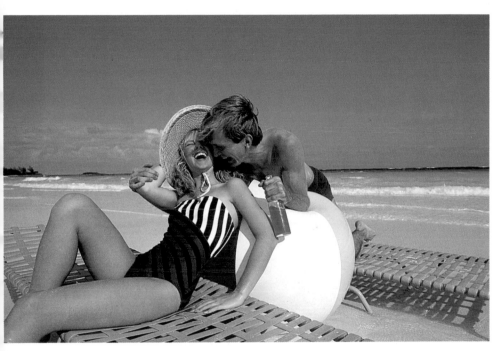

Occasionally when things are slow and I have some ideas that I want to work with, I will put together a stock shoot. This gives me total freedom to express myself creatively and at the same time to expand my portfolio. These pictures came from a stock shoot that I did in the Bahamas. I was having a slow period, and thought it might be great to get some models together and go to the Bahamas to shoot some new pictures for my portfolio and for stock sales. I really wanted to shoot more "people" pictures, because my book was then filled primarily with landscapes, cars, and corporate work. By shooting pictures that would eventually end up in a stock agency, I knew that I would be able to recoup my expenses and eventually make a profit.

I called some model agencies and told them I was going to be "testing." In response, they sent me some new models who were willing to work for a low fee because they wanted to build up their portfolios. My ideas for topics were loose, but I knew I wanted to shoot people on the beach—people with rafts, people exercising, and acting like lovers. Other than these general ideas, I wanted to go with the flow. We put together props and wardrobe typical of couples vacationing in the Bahamas, and to make the shoot more comfortable I rented two beach houses next door to each other, one for the staff and one for the models.

We started each day at 5:30 AM. The models began in makeup and wardrobe while the assistants collected equipment and prepped the shooting location. I worked my ideas around what the environment presented and the models' personalities. We broke for a long lunch between 11:00 AM and 2:30 PM because the sun was too harsh, and then resumed shooting until sunset. We worked for six days, and every evening after the models went to bed, the staff met to plan the next day's shooting.

When it was all over, I had shot three hundred rolls of film. The final edit yielded seven thousand chromes. The shoot cost twenty-eight thousand dollars (the assistants and models were paid). It took us a year to recoup our expenses through stock sales, and now we are making a profit of two to three thousand dollars each quarter that The Image Bank sends out its checks. I wasn't aiming for any particular market, publishers, or advertisers, but I made sure to shoot a lot of variations on each theme by doing different cropping (tight, wide, left clear, and right clear) and both horizontal and vertical framing. The more variations I provide, the more likely I am to sell stock pictures.

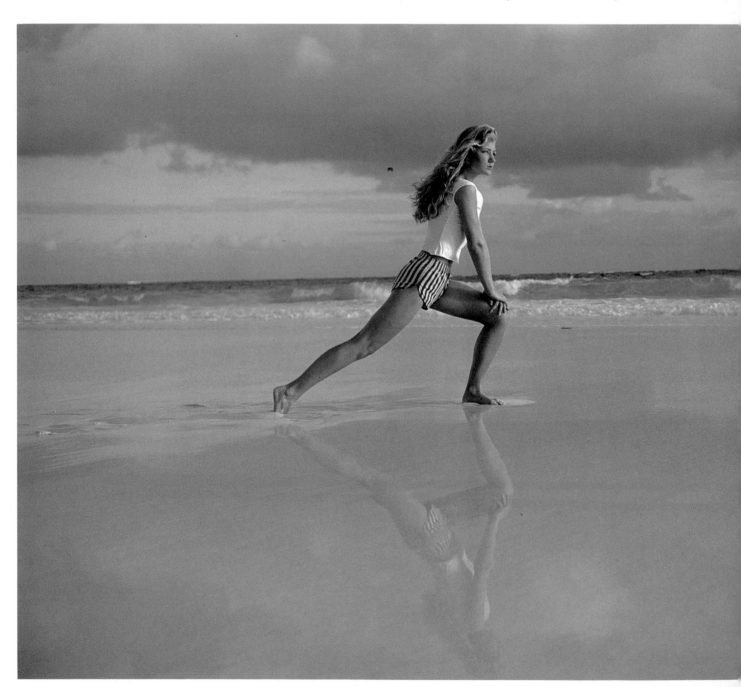

Stock Photography

Stock photography is big business. With the rising costs of sending photographers out on location and with advertising's ever-tightening deadlines, it makes sense for advertising agencies to rely more heavily on using stock photos. Frequently an art director will check stock first to see if anything exists before making an assignment. If you don't have pictures available at a stock agency, then eventually you cheat yourself of these sales. Moreover, you can double your income from a shoot by making its chromes earn a second income through stock sales. Believe it or not, there are photographers who earn their living solely by shooting for stock. They pick a subject, create their own assignment, and shoot it—and they make a great living doing photography this way.

The crème de la crème of stock agencies worldwide is The Image Bank, which has revolutionized the business of stock sales. Eleven years ago, The Image Bank went after the virtually undiscovered advertising market. Today The Image Bank has franchises around the world, and it tops all other stock agencies in sales by leaps and bounds. The Image Bank represents the top photographic talent in stock sales, which includes Al Satterwhite. He has been with The Image Bank for ten years and is very happy about his association with it. His stock income quadrupled during the first five years of using its representation, and his income has risen steadily since then.

When Al is out shooting on specific assignments, he sometimes sees unrelated shots and grabs them. A lot of these go into stock. Some of the work he does for advertising can end up in stock, too, but never before his client's usage limitations have expired. This usually means years, depending on the usage rights sold to the client. Al now keeps only his personal work and portfolio samples on hand—everything else gets sent to The Image Bank, which he feels makes good business sense because it frees him from having to deal with a lot of individual stock agencies.

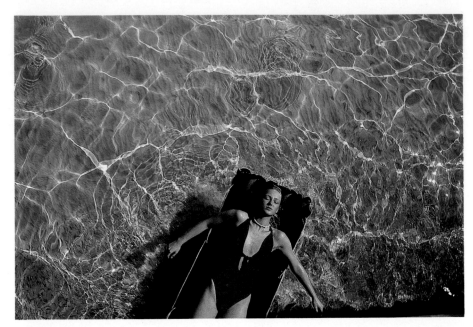

From Where I Sit— Lenore Herson

Eleven years ago The Image Bank opened its doors for business. But we didn't want to follow the other stock agencies. We wanted to break new ground and set new standards. We decided to tackle an industry previously untapped for stock sales, and so we targeted advertising. At first it wasn't easy convincing art directors to think in terms of stock images for their ads. But as the quality of the stock photos submitted to them improved, art directors became more interested and seriously began to consider using stock photos. Our goal wasn't to sell quantity, but rather to establish quality. We wanted the best photographers. We wanted our repertoire of chromes to have style and design—informative shots were not enough.

In advertising we saw a good market for pictures that were art in themselves. It made sense that the better our photographers were, the more sales we could generate. To be the best we had to represent the best. We have been successful—most other stock agencies have a sales split between eighty percent editorial accounts and twenty percent advertising accounts. At The Image Bank, it's the other way around: eighty percent advertising and twenty percent editorial. [Editorial fee scales are from one hundred and fifty to five hundred dollars; advertising can range from one thousand to ten thousand dollars.]

Photographers who try to sell their own work aren't doing themselves justice. Their energy should be concentrated on shooting, not selling. We have a very sophisticated network for selling images worldwide. We are constantly thinking of new ways to get the photographer's work out into the market, so the potential stock client becomes more aware of the quality of stock photos available. We strive to stay current with the times. We are aggressively progressive. Negotiating and selling stock usage is a full-time job for many people, and it's a big business.

Photographers who are considering stock sales for income must be talented. There must be something unique about their work; something that makes their shot stand out from all the others on any given subject; something that makes their shot be selected. Style and design are the important elements in this business. All subjects sell—there is good money in people pictures, but futuristic and still-life photography do well, too. In fact, we have a photographer who specializes in the weather. He has a shot of lightning that is our best-selling catalogue image.

We constantly look at new photographers, but we are very selective about who we take in. We have 350 photographers, and we strive to keep that number constant. By controlling the supply of good images, we help successful photographers earn more. We look at hundreds of portfolios in a year and often accept only a few of them. It is important to keep "up" on who's out there shooting. If a photographer is interested in submitting work for review, he merely has to phone or write the editing department of The Image Bank, and our staff will arrange to look at his portfolio. We have an open-door policy here so no one should feel intimidated. Photographers not located in the U.S. should contact The Image Bank closest to them. We have offices in most countries.

Before photographers consider submitting work, they should already have five to ten thousand *good* images. Once accepted by us, photographers will be given instructions on how to submit their work to the editing department. There is a specific way that we like our chromes labeled and stamped. We also request that one quadrant of the transparency mount remain blank. In our endeavor to hasten additions to our files, we now use a Trac Imprinter that eliminates the need for numbering each chrome by hand. The bulk of the work submitted is 35mm but we do accept other formats, especially from still-life photographers.

I like to stress that our clients are continually looking for *new* material, so it is important that our photographers keep shooting. We have had to drop photographers when the quantity of their submissions fell too low to keep up with the ever-changing market. We are in a new era of stock photography, and although we understand that we are what we are because of the high quality of our photographers, we can't afford to lose sight of where we are going. We have to keep up with changing technology. Our marketing tools are changing, too—we print yearly catalogs and are developing video discs that store up to a hundred thousand images. The bottom line in our business may be sales, but the quality of the work we sell, our marketing skills, and our business integrity have made us and keep us number one.

THE **IMAGE** BANK™

LENORE HERSON
Vice President

633 THIRD AVENUE, NEW YORK, N.Y. 10017/(212) 953-0303/TELEX: 42 93 80 IMAGE

135

Promoting Yourself

People can't hire you as a photographer if they don't know you exist. The point of promotion is to get your name—and your work—out there in front of the buyers. Think of yourself and your photography as a product and the art directors and photo buyers as consumers. Devise a campaign to reach them, just as any company would do to promote their wares.

It helps when starting out to have some sort of focus—what type of work are you trying to solicit? Every part of your campaign should then be tailored to showing the best of your work in that area. Get your portfolios together; you should have at least three for editorial, five or six for corporate and advertising work. You want to have as many circulating as possible.

Spend the money to put together attractive, well thought-out presentations. You can show slides or prints, but many clients don't have the proper setup to view slides, so always have a back-up book available. Make sure the case is sturdy and your prints well mounted, and have the work arranged in a logical and dynamic manner. The packaging is just as important as the photographs to art directors and other potential clients. Many times your portfolio is their first impression of you, so put your best foot forward—it can give you the edge over the competition.

Once you've got your portfolios together, you've got to get them into the hands of interested parties. Have a well-designed advertisement made and send it out as a mailing piece. The emphasis here is on quality. Don't forget, the people you'll be trying to reach are just as creative in their own fields as you consider yourself to be. A mailer that doesn't hold their interest will go right in the wastebasket. Make your ad provocative; use it to challenge them and make them want to see more of your work. I had a mailer produced for Al based on the results of the campaign that he photographed for Molson Golden Ale. We wanted to present ourselves as a creative photographic studio that solved problems for our clients. The response to the piece has been terrific.

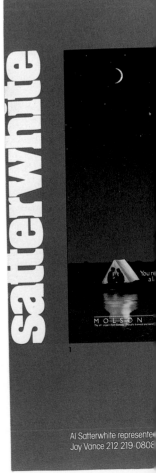

Joy came up with the fantastic idea behind this promotion piece. It folds into three sections, and the question posed on the front cover flap hooks the reader into opening the brochure and giving my work inside a closer look.

136

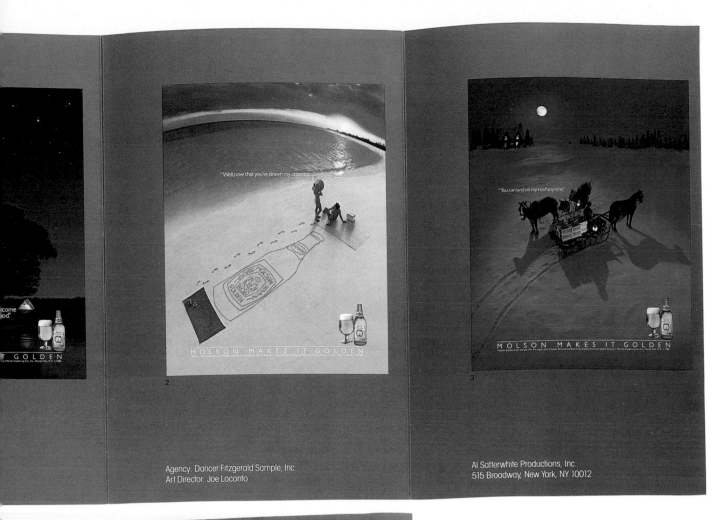

Agency: Dancer Fitzgerald Sample, Inc.
Art Director: Joe Loconto

Al Satterwhite Productions, Inc.
515 Broadway, New York, NY 10012

For an answer call the
studio. While you're at it
ask to see the book.

We create solutions
and great pictures.

Promoting Yourself

Don't be cheap about your mailer—hire a designer to help you put the piece together and get a printer who does high-quality work. Your designer can also help you create a logo for your name. It's important to have an image that will make your name more familiar to the buyers—they'll be more likely to make an appointment with you.

You can buy pre-printed labels from many sources who advertise their mailing lists for sale. Check with your local photographic associations or the annual trade publications, such as those discussed below, for sources.

Apply for a bulk mail permit from the post office—it can cut your mailing costs in half. You'll be sending anywhere from 2,000 to 5,000 pieces, so postal charges really add up. The post office will help you apply for the permit and also give you a book on how to organize your bulk mail. I can't stress how important a mailer can be in introducing your name to clients. They may not always remember your work, but getting them to remember your name is more than half the battle. After all, they're not going to be looking in the phone book under "the guy who takes great still lifes," are they?

As your business begins to grow, you'll want to consider taking advertisements in the photographic trade annuals, such as *American Showcase*, *The Black Book*, or the *ASMP Book*. These are great reference books for "creatives" and are often scanned by photography buyers. Published annually and made up of advertising pages bought by individual photographers, the books are distributed free to a listing of art directors and other photo buyers across the country and are available for sale in book and camera stores as well. The current single page rate for *American Showcase* ranges from $2,400 to $3,000. *The Black Book* charges $5,000 per page, and a page in the *ASMP Book* will cost you $1,850. If you have the money, I highly recommend that you take a page in at least one of these. The exposure is excellent and can help to get your name known across the

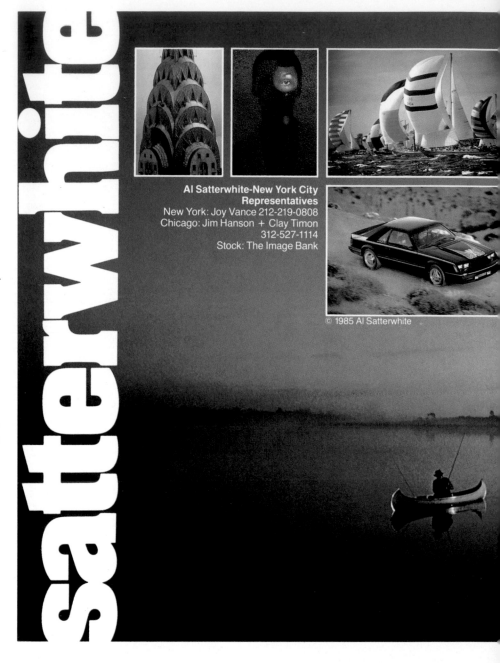

Al Satterwhite-New York City
Representatives
New York: Joy Vance 212-219-0808
Chicago: Jim Hanson + Clay Timon
312-527-1114
Stock: The Image Bank

© 1985 Al Satterwhite

country. Most publications offer free reprints of your ad, printed on heavy card stock. This saves you the extra expense of having cards printed up as mailers, or as "leave behinds" for interviews.

Printed materials can't do the whole job, though—you've still got to get out there and hustle. Copy your mailing list and use it as a phone-call log. Contact the art directors and photo buyers by phone to make appointments for personal viewings of your portfolio. And don't

be put off by people with "drop-off" policies; the market is flooded with photographers who contact the same people day-in and day-out. Buyers don't have a lot of time during the day, so they usually like to screen portfolios during unscheduled free moments. Keep a log of those people who only see books on a drop-off basis and when you have a portfolio available, send them one.

Follow up and be organized—don't let your efforts thus far go to waste. Keep a log of who you see

Al Satterwhite-New York City
Representatives
New York: Joy Vance 212-219-0808
Chicago: Jim Hanson + Clay Timon
312-527-1114
Stock: The Image Bank

© 1985 Al Satterwhite

and what they work on. Most importantly, make notes on what comments were made. They may ask you to get back in touch with them at a later date for a certain project, or they may want to see samples of something you don't have in your book right now. Make a note to recontact these people at the appropriate time. Make sure to visit or call interested art directors and photo buyers at least once every six months. Keep at it and eventually they'll start calling you first.

This is the ad I ran in the ASMP Book *in 1985. Like most photography reference book publishers, ASMP sent me free reprints to use for promotion.*

with Style

...CARS

Al Satterwhite

Represented by:

Joy Vance

212-219-0808

Satterwhite Productions, Inc.

515 Broadway

New York, NY 10012

...ACTION

...PEOPLE/BEAUTY OR ANYTHING!

From Where I Sit— Joe Loconto

It's important for an art director in advertising to try to be different. I use my imagination to create an ad, but a decision then has to be made on how to bring that idea to fruition. The photographer I select will play an important part in the ultimate success of my layout—and I can't afford to take a chance on the outcome.

I go through a process of elimination when I review photographers' portfolios. I like to "discover" my own talent, but I also want to go with a known quantity. I want to see evidence in the photographer's book that he can handle the job. After all, I have to sell the photographer to my client too. I can't just say, "See this picture of a tomato? Trust me, this guy can shoot great locations!"

To me, it isn't important to see a lot of tear sheets in a portfolio. In fact, I prefer looking at a good test shot over a poorly created ad. Even if the photography is good, a low-quality advertisement is an insult to my taste and design sense—and it makes me wonder about the photographer's own judgement.

I don't really have much to go on when a portfolio is sent to my office, so I'm not just looking at the pictures (although they're the bottom line), but the whole package. A good presentation is important and a sloppy book is a deterrent. I like to see portfolios that are well thought out. If a photographer doesn't take enough pride in his work to mount it carefully then I don't want him shooting my layouts.

A rep is important too. An annoying or "pushy" rep might make me hesitate to hire a photographer. I feel that reps should be involved with their photographers' work. Reps should know where, how, and why something was done—I'm impressed when they can answer my questions. In many ways, a rep is the same as a portfolio. My judgement of the photographer is based on how, or who, he chooses to represent him. If you work in fashion and your rep is a doddering old woman, I'm going to wonder about your judgement.

I also like to meet with the photographer before I ask him to bid. A photographer's personality is important to me—I want to feel we can work together. I won't tolerate arrogance. There will be times when the photographer will have to address my client and I don't want to be embarrassed by his behavior.

I take a lot of pride in my work and I expect photographers to do the same. It can take a couple of weeks for me to come up with the idea for an advertisement. It can then take anywhere from two to six months for the idea to be approved. Human nature and insertion dates being what they are, there's always a limit on the time we have to shoot. Practically all of my jobs are rush ones. That's the biggest reason why I can't take chances.

There are always problems on a shoot— especially a location shoot where there's always an unknown factor just waiting to happen. I don't blame the problems on the photographer, but I do judge him on how he handles them. I'm always impressed by good production and good resources. And if the photographer selects a good crew, then I trust him even more. When a photographer has confidence in his operation, I relax a little, knowing the end result will be a great shot.

Joe Loconto

Dancer Fitzgerald Sample, Inc.

405 Lexington Avenue
New York, N.Y. 10174
(212) 661·0800

Printing my last name in the same typeface on all my promotional pieces gives the creatives a trademark to associate with my work. The red type on this flyer may also help jog their memories.

141

Index

Editorial concept by Marisa Bulzone
Edited by Marisa Bulzone and Robin Simmen
Designed by Jay Anning
Graphic production by Ellen Greene